THE ART

OF

SELLING ART

SECOND EDITION

THE ART

OF

SELLING ART

SECOND EDITION

by Zella Jackson

THE CONSULTANT PRESS, LTD.
New York, New York

PUBLISHED BY:
THE CONSULTANT PRESS
163 AMSTERDAM AVENUE
NEW YORK, NEW YORK 10023
(212) 838-8640

Susan P. Levy, Editor

Library of Congress Number 94-068416

ISBN 0-913069-48-5

Printed and bound in the United States Of America

TABLE OF CONTENTS

FOREWORD - SECOND EDITION

To the average observer, success in any chosen endeavor is usually viewed as some kind of magical fluke or a monumental "lucky" break. Luck is involved when it is defined as the moment in time when preparation meets opportunity. Business success in the art world depends on preparation. An art dealer should never try to discuss a work of art without knowing the name of the artist and what style is used, but so many art dealers neglect to prepare the techniques of *how* to sell art — the art of the sale. Study and internalize the information in this book, and you will discover that this "preparation step" is the foundation for your success and effectiveness in the industry.

I am excited to be given this opportunity to express my admiration and appreciation to one of the greatest sales trainers of our time — Zella Jackson. Zella was influential in helping us build a strong foundation for our gallery by showing us how to employ the sales techniques responsible for our present success.

In case you are wondering, I am not a paid endorsement. I am just like you. I am constantly searching for various ways to improve my sales skills, business acumen, and bottom line profit. My name is Lawrence Charles Lewis, and I am the owner and Gallery Director of Lawrence Charles Galleries, a business in which my wife, Cynthia, and I are partners in sunny Tampa, Florida.

I became acquainted with Zella Jackson when my wife and I decided to open a business together. After spending some thirteen years in a business I didn't enjoy, my wife and I searched for a field that could inspire us to achieve greatness. The common passion we share is for collecting contemporary art, so after great consideration we decided to open a retail art gallery. Although neither one of us has a formal education in the arts, I have many years of sales and marketing experience, and my wife has an MBA in finance and accounting. Together, we knew our combined talents were sure to be the formula for success.

The first month in business we came to the sharp realization that it takes more than the right gallery location, high quality art and friendly salespeople to be a leader in this industry. Although the preceding three ingredients are satisfactory for moderate success, we felt that an essential ingredient was missing in our formula for greatness. I desperately ordered every sales book available but couldn't find one related directly to the sale of art. My efforts were rewarded when I discovered the first edition of Zella Jackson's *The Art of Selling Art*.

I was relieved and inspired to find Zella's collection of "real world" art presentation and negotiation techniques from opening to close. This manual not only

employs academic theory but also demonstrates "hands on" methods that guarantee results. I was so motivated after reading this book and getting instant results that I called the publisher to get Zella's number in Hawaii, and I was equally impressed at how eager Zella was to take my call. Our first conversation was over a year ago in the fall of 1992, and since that time Zella has come to Tampa, Florida from Hawaii to train our art consultants in our own gallery setting. Our gallery now lives by Zella's training program through use of her books and video training series. Perhaps the most dramatic impact Zella had on our gallery was her handling of one of our shows in June of 1993. She modified our invitations, wrote our pre-show reception letter, and even did the unveiling and accompanying romance of the featured artist for our invited guests. The way she was able to build value and urgency, and to create a mystique surrounding the artist resulted in the sale of nearly every one of his paintings in the show.

In just a very short period our sales production has been propelled to new and ever-increasing levels. We attribute this success to our association with Zella — she works with us as a coach: sharing her insight, commitment, and passion that is always present and inspiring.

The Art of Selling Art should be used as your reference manual. It provides an arsenal of tools for adding lasting enrichment to the quality and success of your business. The information contained in this book will help create an environment in which talent can flourish. The secrets are all here — but you must make the effort to study and utilize the material to blaze your own personal path to greatness.

Lawrence Charles Lewis, Director
Lawrence Charles Galleries
Tampa, Florida

AUTHOR'S FOREWORD

Oh, what a journey it has been . . . from advising the tiniest of galleries to romping with the rich and famous from around the globe. I have dialogued and done business with unknown entrepreneurial artists as well as internationally renowned artists; with the small first-time publisher and the largest art publishers in the world; with ambitious husband and wife teams putting their life savings on the line and the mega-rich art business investors.

And yet, I will never lose sight of where it all began: in an unknown art gallery in a tiny resort town on the remote island of Maui. To all my "students" then and now — I say thank you. Without you, I would have no book to write. I wish to dedicate this volume to all of you who have attended my workshops, read my books, tried the techniques, and prospered. It is to all of you that I am eternally indebted.

It is also because of you that I thoughtfully revise and update *The Art of Selling Art*. The nineties have clearly brought new challenges to our centuries old art industry. The revisions in this edition reflect an urgent need to pay greater attention to quality and service in order to create a lifelong client.

Because of these changes, I am updating this volume and have authored another book entitled, *The Art of Creating Collectors*. The new book provides a strategic and operational look at how to systematically create lifelong repeat buyers..... collectors. I encourage you to read it as well to develop your own comprehensive art marketing and sales program.

Also, my third generation video training program is available. This Video Academy offers almost seven hours of video training and comes with a hardbound workbook. I designed it so that you could have mini-workshops right in your own gallery or showroom with teams as small as two and as large as thirty. The feedback so far has been very positive. Call my publisher to order. In fact, write to me (care of my publisher) if you have any questions about how you can get your art marketing and sales program working more effectively, or write to provide us with some feedback on what is working well for you.

In closing, I would like to thank my devoted husband and business partner, Larry Underhill. He has been a beacon of light for me throughout our fifteen years of marriage. Our son, Larry Jr., shines for us both.

Someone wise once said that while dreams may inspire, nothing pays like action. So take these methods and techniques, put them to work, and they will work for you. Happy journey!

INTRODUCTION

The world of fine art retailing is experiencing a revolution. Gone are the days when an art gallery owner or art consultant could sit back and play snob. Gone forever are the days when the art consultant could say, "If you have to ask how much it is, you can't afford it," because the clientele that stood for that "treatment" are dead and dying. And your art gallery business is either dead or dying if you don't change to accommodate the new market that's growing and expanding.

The New Market

The new market is well-educated and demanding and requires good service and many options. While many need to be educated about the world of fine art, they will gladly write you a check for $50,000 even though forty-five minutes earlier they had never heard of the artist... as long as you understand and meet the demands of This New Market.

This alive and growing market is made up of managers and their support staffs, small business owners and their profit-sharing employees, the researcher and his/her assistant, the supervisor, and the "quality circle" assembly-line worker. America has one of the best educated masses of high wage earners in the world. And not only are they educated, but they are also savvy and assertive about what they expect to have (e.g., "Don't give me just another raise; I want a 'piece of the action' "). And what they expect to have is an exceptional way of life. Never have so many worked so little and expected so much. The way of our modern world is to work smart, not hard. They... I mean, WE are either in the process of becoming or already have become self-actualized. And what this revolution means to us fine art retailers is that, if we want to be a part of it, we must change.

The art collectors of the nineties have tightened their purse strings. While an art collector may very well spend that $50,000 — it better be for artwork that has tremendous value. If you can not substantiate artistic value — forget it. The art buyer of the nineties prefers packages to achieve additional value for every dollar. You must recognize that the majority of your marketing campaigns should be targeted for volume sales at lower average price points than those of the eighties.

Moreover, art retailers will need to concentrate at least half of their time on direct selling: conducting private appointments in the client's home or office; designing, and mailing promotions; calling prior buyers; renting retail space at home shows, farm fairs, and other non-traditional trade shows. In short, you will have to "take the art to the people" because the people are not coming to you. While there are a few notable

exceptions in key retailing hot spots, most of us have to contend with far fewer prospects and a lower percentage of new buyers each month.

Since the art buyers are more conservative, you will find that a smaller retail space or an "open-by-appointment" showroom will send the most appropriate message to your clientele. Plus, since much of your sales activity will be direct, the need for large, elaborate, expensive retail space becomes less important.

In order for you to give your clientele the best value, you will want to buy inventory at the lowest prices available rather than consign it. If you have the capital, publish your own staple of artists. While this involves risk, it is a risk worth taking. You will want to have the most control as possible over your cost of goods while empowering yourself. Think about it: Won't you purchase and display only the best art your money can buy? And won't you sell that inventory as effectively as possible?

Thus, changes are necessary for many of you to survive; some of you will not only survive but thrive in this new, more challenging environment. Remember, wait-and-sell is a thing of the past. Gone are the days when you could make a sale and forget the person's name that afternoon. To sell to a buyer only once is both foolish and irresponsible — a complete and utter waste of your time and the buyer's. Make the changes mentioned above and discussed throughout this book to create a loyal clientele—collectors who buy from you again and again — that will allow your art firm to flourish in the nineties.

The Changes

The changes required to tap into the new market are many. First, you must change the way you think of the client. Instead of having a "compliant checkbook" or a "hardball deal-maker," whereby not-so-subtle techniques would help you nail down the sale... you may have the deliberator who won't be pushed but seeks to be pulled, or the "up and comer" who won't be snubbed but seeks to be wooed.

Second, you must change the way you sell. Instead of manipulative techniques (e.g., "turnovers" in the closing room), you must rely on a consultative selling approach that not only keeps the client's ego intact but also strengthens it.

Third, you must change the way you market your art. Instead of "semiarbitrary" pricing and "seat of the pants" consignment policies (for resales), you must have sophisticated marketing strategies for each contemporary artist you develop, and you must follow more closely the industry standards for deceased artists. Also, you must stand behind your art in a way many retailers never bothered to before. In short, you must support your secondary (resale) market.

The Payoff

The exhilarating rewards you will reap are vast. To replace the old "win/lose" approach with the new "win/win" one is to be a better human being. It allows us all to operate at a higher level of consciousness that is stimulating and growth-oriented.

Further your art consultants and support staff (who are also a part of the revolution) will be loyal, trustworthy, and productive.

Last, everyone involved in your art gallery business (YOU, your artists, art consultants, administrative and shipping personnel) will enjoy wealth and prosperity beyond their wildest dreams.

I am excited to share what I have learned over the years in this exciting NEW industry. My top "students" earn six-figure incomes as art consultants, and the business owners have become solid millionaires. And, more important, these people have adopted a fine art retailing philosophy that is forthright and effective. They build the esteem of others and maintain their own integrity. They work smart, not hard. They experience the world through travel and cultural revelation. And finally, they enjoy the hell out of what they do.

And... with this guide in hand and a genuine love of people in heart... so shall you.

Who Can Benefit?

Anyone who sells art... any kind of art and in any capacity. While I will use lavishly the phrases "Fine Art Retailer" and "(Retail) Art Consultant," Wholesalers, Artists, (Corporate) Art Consultants, Gallery Owners, Gallery (Sales) Directors, Independent Art Dealers, Home-based Art Reps., and others can benefit equally.

Study those areas that you are most receptive to first. I want you to experience early success with some small change(s) and grow from there. If you hit a section that is just not your "cup o' tea," skip it for now. Come back to it later after you have experienced some success. If you feel you are entirely receptive!?!?... begin here.

I have been working with my clients for many years now, and they are all very successful. I know how to sell art, myself. As Executive Director of The Fine Art Network, I successfully work the sales floor at major art shows that we sponsor for our dealers. I also sell art to the commercial art buying segment — interior design firms, architectural design firms, brokers, and business owners.

In addition, as a consultant I work with art gallery owners and their staffs throughout the United States. With the owners, I work on marketing strategy and

implementation plans; with the sales staff, I work on selling techniques that build artistic value; with the "back office" staff, I emphasize high quality support services. In many cases, I have worked on behalf of my clients on the floor from time to time with their novice salespeople, particularly people who have never worked in fine art sales before. They like to have me down there without the sales manager there to direct them, so they can ask "dumb" questions (no such thing!). I've been in the position of closing sales with that first-time buyer whom I met only an hour ago! I love it. It keeps me sharp, and it keeps me charged. More important, my students do well after I work with them, even if they were "starving" at first.

Do you have any salespeople who are starving on a commission-only basis? Yes, Starving! They come to work dressed well, and they look like they are successful in a beautiful gallery. And they can't pay the rent! I had one guy who was living in a van; it was really sad. But the good news is: when I start working with these people, in a matter of months, weeks and sometimes days, they go from a thousand dollars per month to two, three, four, five, six, seven, eight, nine, ten thousand dollars a month! Isn't that incredible? Absolutely incredible! And I'm talking about people, some of whom are high school dropouts. I'm talking about people who run the gamut. Some of them are very, very well-educated. Sometimes I get them from the layoff line. It doesn't seem to matter; they come from all walks of life. What seems to matter most are some of these things that I am going to touch on. You'll want to examine them in yourself, as you wear that consultant hat, and you'll want to examine them in the people you rely on. If they don't have these qualities, then no matter what you do with them, they're not going to be successful in this business.

The Dream

Number One, with the people you rely on, as well as yourself, you've got to have a dream. Now that sounds esoteric, but I word it that way because all of us are really goal-oriented; we carry day-timers around, and so on and so forth, but quite honestly, to write a dollar figure down for what you plan to sell isn't really motivating, is it? Money doesn't motivate anyone. It's what you want to do with the money. Isn't that true? And one of the things I hope for with my "students" is that they can get their lives together first, and then I give them the road map, and they become successful on their own. So you have to have something big within yourself that keeps you going. Boy, when that client walks in and gives you a dirty look, or is rude to you, somehow it doesn't matter because you know that you're doing this for a very big reason. I'll tell you about a few people who have done quite well in this business.

Gary Smith

When I first met Gary, he was one of those starving art consultants. Now he is a Superstar earning a six-figure income.

I met Gary six years ago. He, like many, was tired of the mainland rat-race and had retired early on the remote island of Maui. The tranquil tropics also happened to be a great inspiration for his artist-wife, Andrea, who began to paint the best work of her life. But, Gary was a bum: he looked like one, thought like one and acted like one. He wore cut-off shorts, flip-flop sandals on dirty feet, and frumpy cotton T-tops. He had no direction in his life and came to work as an art consultant with this mess of a life. And, not surprisingly, he sold very little art.

When he got clear that he wanted to support Andrea in becoming a world-class artist and that's what was really driving him, suddenly he had inspiration to dress up, handle objections, and do what was necessary. He looked forward to the long days and long nights in order to get where he and Andrea were destined to be: creatively and financially successful.

Patrice Williams

One woman I worked with, Patrice Williams, is an example of someone who took off in a matter of days. She had been a waitress. She was twenty-one. She came to Hawaii to hang out - cool out. She didn't try to work too hard; while she wanted to travel, it was her thing to bum around in each little town and just get by. I said, "Patrice, you're a very talented lady. Why don't you make this work for you? Then you can take your long vacations whenever you want, and you won't have to starve while you're on your vacations! You can enjoy it! Take this class." She thought about it. We outlined a program, an itinerary of travel for her. I helped her to really think about her life and how she could utilize this profession seriously to get her life in order. And I made clear to her that it could happen if she wanted it. That very afternoon, she wrote up about five-thousand dollars in sales. That following day, she wrote up about ten-thousand dollars in sales. I'm talking about a woman who never sold before! Now I should preface this by saying that the previous week I had taken her through my entire course. In fact, the owner of her gallery was one of these very wise entrepreneurial types who realized that he couldn't give his people this kind of training, so he got me to do it. She had all these tools at her fingertips, and she just simply decided to use them. Isn't that something? Absolutely inspirational!

By the way, the real inspiration I get is from the people I work with, and I hope you feel that same way about the people you rely on. First, they must think big — something bigger than themselves - something other than just paying the rent because,

if all you want to do is just pay the rent, that's all you're going to be able to do! And you want to make your people face that. Then, you can assist them with having specific and vivid goals because then the dollar signs — their professional goals — will mean something.

This will give them the persistence they need to be successful. One of the things that Patrice did that I was so impressed with occurred when a couple who were her clients wanted an original R.C. Gorman. They didn't have any in the gallery at the time, and she said, "Well, I'll get you one." Her clients were just visiting the resort town and replied, "We're going to be here only a few days." She said, "No problem; I'll get one." She woke up early in the morning and overcame incredible odds to have an R.C. Gorman original sent to Lahaina. And let me tell you, that is a tough job. Lahaina's out in the middle of nowhere, in the middle of the Pacific Ocean! And 10 and behold after all this effort, it wasn't quite going to get there in time. In fact, the clients were leaving to go to the airport when the piece was being delivered at the airport. You know what she decided to do? She said, "I'll tell you what, I'll meet you at the airport." She went down there, uncrated the piece in this little airport and, standing there with this exquisite work of art, and her clients, she sold it on the spot. Isn't that something? That's incredible! It was about a fifteen-thousand dollar sale. That's what it takes: persistence that is buoyed by one's own self-inspired vision of success.

Candice Price

Candice lives and works in Kansas City and is a wonderfully delightful lady. I feel this even though we have never met in person! Candice and I had many phone conversations in which we brainstormed ways for her to enhance her small art business. You see, she has taken advantage of my Fine Art Network Dealership program and has become a home-based art dealer in her spare time. While she had never sold art before, she had a dream to provide people of color an opportunity to surround themselves with art glorifying the African-American experience. Since our dealership program offers a full spectrum of art, we were able to assist her with this dream.

Candice studied our video academy, developed a marketing plan, and sold several of Tolliver's limited edition pieces only a few weeks after joining our program! This African-American, home-based art dealer and single mother of two has started down the path toward financial independence. Her sales continue to be impressive, and she is an inspiration to all who are fortunate enough to know her.

Lawrence Lewis

Lawrence is one of the most charming gentlemen you will ever meet. He graciously agreed to write the foreword for the second edition of this book. He and his wife have been very generous with their support of my programs. I think you might be inspired by their story.

When inexperienced business people feel they have benefited from my programs, that is one thing. When savvy, articulate, collegiately trained, experienced business people feel that way, I get really jazzed. Lawrence has had thirteen years of business experience, much of it in sales; his wife Cynthia, has an M.B.A.! What a power house of a team these folks are. Our very first project together resulted in a sell-out show. I recently spoke to him, and he said simply, "When you can increase your results by tenfold by following your program — there is no question in my mind that it works!".

Lawrence and Cynthia have *duplicated* the results of our first show together, and their gallery in Tampa continues to prosper. Isn't that fantastic?

Selling Is a Gift

Great salespeople believe that selling is their gift. All of my superstars — the Gary Smiths, the Patrice Williamses, the Candice Prices — believe that there is something very, very special about them that they bring to this profession. Many people get into sales because no one will hire them for anything else. Have you ever fallen into that trap as art gallery owners? Do you hire people who literally can't get hired doing anything else? Do you check references when people come to you? Two of the most important things you want to ask are, "What did you sell before?" and "How much did you sell before — per month?"... and verify it. If they haven't been selling more than ten or twenty-thousand dollars worth of something per month, what makes you think they're going to be able to do that with you? And if you're dealing with higher-end art, in particular, do you think they're going to be intimidated at a $100,000 price tag? I assure you, this is very important. But these people think, "Well, gee, I'm good with people." And you ask them, "What is it about you...?" And you're going to ask yourself this when you wear the art consultant hat: "What is it about me that I bring to this profession?" Give yourself that pep talk when you need it.

A Willingness to Be Flexible

This is where a lot of people agree with me intellectually, that one of the keys to being a superstar is a willingness to be flexible. They tell me, "Oh, yeah, I'm flexible. I

appreciate the fact that people have different styles. In fact, if Mr. Rude walks in and he likes the painting that I wouldn't have in my basement, I can appreciate that."

But, in actuality, most of us have a difficult time executing that intellectual concept because when they walk up to the painting that we wouldn't have in our basement, we have a difficult time elaborating on the beauty and exquisiteness of the piece and how it's going to be perfect for them. Have any of you had that feeling any of you at some point or other? To be a superstar in this business, you have got to not only intellectually understand that people have difference styles and tastes, but you also have to go with their flow.

One of the main messages that I want to share with you is that it doesn't matter one iota what you like. Not one iota. What matters is what your client falls in love with. Your job literally is to leave yourself mentally and spiritually and become the other person. Get inside their mind's eye; see their living room, their corporate office, and say with all honesty and sincerity, "Well, you know what — based on who you are, and your tastes, and your furniture, your decor, your likes, your loves —this would be perfect for you."

But, what if it reflects badly on you? Many art consultants object to this, saying, "If you feel that they're really barking up the wrong tree, and if it's something you think you wouldn't have in your basement but they want this up front in their office — what a dilemma! Now, if you are selling the art, will people feel you have poor taste and judgment? The answer is NO because art is a reflection of the owner.

Now this is something that I firmly believe. It is not solely my opinion; I'm relating the belief of hundreds and hundreds of people who are very successful in this business. This is what we feel. Number One, art is a very, very personal acquisition. People will associate the art with the person. I assure you that the people who come to know that person will identify with why that person fell in love with his or her artwork. Do you see? The association will be with the individual. Remember, when people buy art, they are connecting with their emotions. It's a love affair; it's chemistry.

A Balanced Life

Another important key to success in this or any profession is having a full, balanced life — physically, emotionally, and spiritually. What good is extraordinary success without your health or good personal relationships? Who desires personal fortune at the expense of a corrupt soul? Hopefully all of you strive to enjoy a balanced life. This concept is a hard one for many because they get so hung up on making the dollar. One fellow I know in the industry got on such a treadmill of art shows that

required a great deal of long distance travel that by the time he got home after one particularly long trip, he first realized that his wife and children had left weeks before. The worst part of this story is he was *surprised* when it happened! Don't let yourself worship money and forsake the very life force that will keep you inspired.

I'm sure all of you have heard that Queen Elizabeth I said just before her death, "All my possessions for one more moment of time." And conversely, when was the last time you heard of someone on her deathbed whispering, "I wish I had spent more time at the office!?!" If you keep a sense of balance in your life, the techniques to help you make more money will always have a sense of purpose.

Belief in the Art, Artist, and Gallery

The last thing necessary for success in the art industry is a belief in the Art. The big problem with most of the art consultants who represented Andrea Smith, for example, in the beginning, was to develop a belief in her work. She didn't have any formal art training: her work initially looks like their ten-year-old kid could do it, and on and on. What they found was that once they understood Andrea and her inspiration and how other people relate to her work emotionally — and what it means spiritually — they could sell their clients. I have one of her paintings, as a matter of fact, in my living room, and I really love it. It's beautiful. It connected for me. Once you are in sync with her philosophy, then suddenly you can sell her work.

In other words, you must again forget about being an art critic (and an unpaid art critic at that!). You must search for the reasons why others connect with the work and align yourself accordingly.

SECTION ONE — KEY STEPS OF SELLING FINE ART

What follows is an overview of the Key Steps of Selling Fine Art. I start with the context of working with gallery clients. Once you are beyond the initial greeting, many similarities exist between that setting and any face-to-face selling scenario. There is also a section on the specific differences between selling art at the client's home/office and selling at the commercial art buyer's office.

First let's examine two important points that you will want to keep in mind that can easily result in a twenty five percent increase in sales, regardless of the setting!

Ten-Percent Increase

If you, one-hundred percent of the time, consistently and properly greet your clients, it will result in ten percent more business on average. So, if you wish to maximize sales one-hundred percent of the time, you will properly greet your clients.

Have you ever had the experience yourself where you walk into a particular retail setting and you're ignored? The salesperson's on the telephone or busy with another client, and here you are, a prospective buyer. And the minutes go by — for some of us it's a minute; for some of us it's several minutes. We all have an internal clock that tells us when we won't take it anymore. Guess what we decide in many cases? To leave! Absolutely. And sometimes, we never come back. This is particularly important for those of you who sell in a resort town. It is particularly important because if they don't buy from you, if they don't connect with you, I assure you, they're going to go down the street and buy from somebody else. This is probably one of the biggest mistakes that I see my "Senior Students" make. They get so fat, dumb and happy working with clients on the phone that they don't want to even look up from the desk or the telephone to talk to the traffic. I assure you, Mr. Moneybags will walk in and walk out so fast that your head will spin. Sometimes when I'm on the floor working with a novice salesperson, s/he will boo-hoo and say, "I can't pay the rent," while I'm greeting a potential client. The art consultant will interject, asking, "Hey, why are you talking to that person? S/he's not qualified. Look at him/her; s/he's dressed like a bum!" In twenty minutes, I will sell that person a thousand dollars worth of art.

What about the proper greeting at the appointment? How many times have you forgotten to reaffirm the amount of time that your client has available and found yourself 50% through your presentation when the prospect has to leave for another meeting? Whether it is a retail setting or at the appointment, a proper greeting can make or break your results.

Fifteen-Percent Increase

This is, again, something you have to do one-hundred percent of the time in order to yield the fifteen-percent increase. Whenever someone is buying from you, always, always suggest the additional acquisition. When a client is in the buying mood, go for it. And that will, on average, add fifteen percent to your gross receipts.

A lot of my consultants feel funny about this. They say, "Gee, what if I lose the other sale? I'll confuse them." We can talk about the subtleties of that as we go along, but very simply, it goes like this: If you're not sophisticated enough in your selling technique at this point to sell packages or in pairs or triplicates, then sell only one painting at a time. Most of the literature will tell you to focus on one thing at a time. That's true if that's what you're comfortable with at this point. And there's a lot to be said for focus. But once you have closed them, you can suggest the additional acquisition. One of the ways that I close them without getting into all the paperwork, *et cetera*, is I shake the person's hand and say, "Well, fantastic, it sounds to me like you're ready to go with this, is that correct? I am really delighted. You are now the proud owner of (mention the title of the piece, et cetera). You're going to love it! (Provide Reassurances.) You know what, though? Before you go, there is another piece I have got to show you." I have reduced the pressure for that eighty-five out of one hundred who are going to say, "No." I say, "You know what? You might not be ready for this now, I don't know, maybe you are, but I'd like to show it to you because if you don't get it right now, ! think you're going to want it later. And you might even want to put it on layaway, I don't know... maybe you'll want to take it now. Why don't we take a look at it, okay?" Then you bring the piece in.

Hard Sell?

Right about here in my public training programs my new "students" become concerned. They say things like, "I have to ask you, you're so personable, and the things that you're saying to us and you ask us to say to the clients, do you really say them?"

The answer is YES. I just don't say it as loudly, that's all. That's the only difference.

But my new "students" persist by saying, "Yes, but because your personality is so charming, you can win people over with that. But the words that you're saying, if you weren't so charming, would be more hard-sell. Because you're so charming, people are just won over. Is that the way it is?"

While I appreciate the compliments, it is not just my charming personality that is successful. My seasoned "students" have also all done very well. If I didn't have so much proof out there from the people I've worked with, I would not have the confidence for those very reasons. I've worked with so many people, with all different personality types. I'm talking about people whose personalities are as exciting as rocks. I'll put it this way: they are soft-spoken, very understated individuals. I've also worked with the flamboyant and colorful and everything in between. It doesn't seem to matter because you can say it soft, you can say it hard. The important thing is to say it. You don't have to use my exact words, but the important thing is that you say, "You know what? There's something else I've got to show you. I don't want you to go without at least taking a look at it. What do you think?" Do you see? We have to ask the clients how they feel because we're doing it for their benefit.

When you encourage your people and yourself to push forward, replace the word "aggressive" with the word "assertive," and it will make it a lot easier for you. In fact, I work with this issue particularly with women. There are so many women in this business, and they have a lot of sociological issues that they're trying to deal with. Lack of assertiveness is one of them, and it translates into many areas in their lives, Sales being one of them. And I encourage them to buy a book by Susan and Anthony Bower entitled, *Asserting Yourself*. It's a workbook designed to help you take one step toward making yourself feel more comfortable with being "out there". It is very different from aggressiveness...very different. Aggressiveness is defined as getting what you want and need at the expense of others. Assertiveness is win/win; it's at no one's expense because you're in an agreement with me because we have a relationship and a rapport. If I've just spent an hour and a half with these people, and we've chitchatted about their kids and their dog, and I know what their house looks like, then they're not going to be offended if I tell them that I'm so excited about a piece that they've got to see... that if they don't see it, they're doing themselves a disservice. Are you kidding? They're going to be just as excited about it as I am. And that's the truth of the matter. And if they're not, then you have failed earlier on in the selling process. You haven't elaborated enough. You haven't won the people over in your own way, whatever your own way is.

I wanted to reinforce the notion of suggesting the additional. Whenever you go into McDonald's and you order a Big Mac, what do they say?

"Do you want fries?"

And if you say, "No," then what do they say?

"How about an apple pie?"

Now, while Burger King and McDonald's are not the best illustrations of this technique, one thing I can assure you is that their corporate training people are so convinced of how important and significant this additional revenue is, that they drill it into those minimum-wage people to the point where they say it even though it's lackluster and without enthusiasm — because it makes that big a difference. So imagine yourself doing it professionally with excitement and enthusiasm and the awareness of what it can mean to your business. Fabulous! It really works! All right, so that's the easy portion of the lesson. Now we'll go on to some of the more challenging material.

What Is Selling Fine Art?

Each of us defines selling in our own special way. I define it in these terms:

Selling Is Helping People Make Decisions

The reason I prefer this definition is that it helps to bring to the forefront of your mind the "How Of It." You see, if you're not assertive — if you're not asking people questions then you're not getting people involved in a dialogue. If you're standing up there playing museum curator and giving them a lecture about the benefits and the beautiful aspects of a painting, then they will walk away confused. In fact, they will tune you out after a while. How long? You can tell — their eyes glaze over. They're gone, but you still talk, hoping that somehow with sheer force of will you can get their money out of their pockets. You've got to have a give-and-take. I can sum it up in these terms: The only way you can facilitate a person's decision-making is through the use of questions. And perhaps the rest of the book will simply unfold what the right questions really are. You want to see yourself as a facilitator.

The Key Steps — Selling Art In The Gallery

The following is my framework of fine art selling and will surely guide you to a strong and prosperous career. The nine key steps of retail selling provide insights into how to successfully sell art in a gallery setting, art show, trade show, and private reception. You may wish to proceed more quickly through the steps whenever there are time constraints or traffic pressures.

1. GREET

2. QUALIFY

3. LISTEN

4. RE-APPROACH

5. SALES PRESENTATION

6. DIMMER ROOM

7. OVERCOME OBJECTIONS

8. FIND REAL OBJECTION

9. FINAL CLOSE

Each step is explored in detail in this section, with one exception: No. 5. — SALES PRESENTATION, will be covered in Section Three. I have included sample scripts for your review; but remember, no script should be memorized verbatim. Rather, use these as ideas, and allow them to stimulate your own thinking. This is the NEW market you are dealing with, and they know when you are fake or genuine. It takes more work up-front, but the rewards are far greater.

STEP 1 — GREETING THE CUSTOMER PROPERLY A CHECKLIST

1. Always appear cheerful and approachable regardless of the demeanor.

2. Open with what feels natural, avoiding those obvious statements that let the client only "look and leave." Also, avoid questions that lead you to a dead end. Asking people where they are from, for example, without an appropriate and quick follow-up can lead you to a dead end.

AVOID: "May I help you?"

"Can I check back with you later?"

"Hi! Where are you from?"

"Hi! Is this your first time here in Hawaii?"

"Were you interested in anything in particular today?"

"Do you have any questions?"

TRY: "Welcome to the gallery! Feel free to look around; I'll check back with you in a few with you in a few minutes to see if you have any questions."

"Hi! Beautiful day in paradise, isn't it? (pause for response) I couldn't help but notice that you were admiring Robert Nelson's new print, *Reflections*. What about it caught your eye?"

"Welcome to our beautiful gallery. Is this your first time here in the gallery?" (pause for short response) (Yes) — "Well, let me tell you how it's laid out..." (No) — "Well, we change it around so much, let me tell you how we have it hung today.."

"Hi, my name is _____; and you...? so nice to meet you both, Mr. and Mrs. _____ Can I show you the most intriguing piece we have in the gallery today? It was just completed and unveiled to the public last week; come right this way..."

REMEMBER... GET THEM INVOLVED AS EARLY AS POSSIBLE...

GREET PROPERLY!

STEP 2 — QUALIFY — QUALIFY — QUALIFY!!!

Ask a qualifying question early on in your discussions with your clients. This can be very subtle and nondisruptive to the flow of conversation as long as you ask it smoothly and confidently. There are some things to watch out for, however, if you haven't smoothed out your presentation. From the mouths of unsure or less-sure art consultants, the qualifying questions below termed AVOID can be hazardous (particularly if used early in the conversation).

AVOID: "Well, do you want to buy it today?"

"Why don't you go ahead and get it?" (This is a hard closing question, not a soft qualifying one.)

TRY: "The one you are admiring is $2500; does that feel comfortable?"

"Do you have a local framer you trust?"

"We have something to fit every budget. For those with unlimited resources, we have fine art originals from $15,000 to over $100,000. For some fortunate few, we have limited edition prints and originals from $800 to $5,000... and for those first-time investors we have pieces that range from $200 to $600. What feels most comfortable with you?"

"Well, you've been admiring this for some time. The investment for this piece is $25,000. Do you feel that this is something you would like to seriously consider?"

"Are you a first-time collector, or are you adding to your collection?"

"Do you prefer originals or fine-quality limited edition prints?"

"What kind of art work do you currently have?"

"Do you already have oriental art work in your home, or will this be your first piece of this genre?"

"Were you looking for something that complements your current collection or for a unique departure?"

STEP 3 — SHUT UP AND LISTEN!

Listening is the hardest step of all. You want desperately to say the right things, but the real key is to hear what the person is saying so you can recommend the right things. Studies have shown that the average person's listening ability is a mere eleven percent. In other words, not only do you retain only eleven percent of what the client says, but the client retains only about eleven percent of what you say. Now, I ask you, how are you going to facilitate a person's decision-making if the two of you are constantly missing each other?

This eleven percent can be improved with simple techniques which require keeping the person involved. For example: (1) Using questions; (2) Writing things down (you and the client — I thoroughly enjoy instructing a client to "write this down" because

I'm certain it's vital to our communication's success); (3) Taking the client on a "test drive" (e.g., the closing room); and (4) Expanding on the client's own thoughts.

How can you tell if you are listening effectively? Well, ask yourself these questions when you have just completed a selling interaction of at least one hour or more:

1. Did I introduce myself within the first ten minutes?

2. Did I use the client's name at least every five minutes?

3. Did I say things like the following frequently and with honesty ?

"Based on what you've shared, it sounds like..."

"If I understand you correctly, you feel..."

"Thank you for sharing that..."

"I appreciate your point of view..."

"Allow me to paraphrase (summarize) what you've said..."

"I'm so excited you had that experience..."

4. Can you complete a demographic profile on the client that is plus or minus ten-percent accurate on such information as:

● Annual Income/Net Worth

● Current Art Collection

● Recent (last three years) Travel

● Future Travel Plans

● Art Buying Motivation(s) (Investment, Decor, Emotion)

● Specific reason(s) client bought or declined the piece you discussed

● Name, Address, Phone Number (and Permission to Recontact)

● Decision-Making Style (Deliberator, Impulsive, Alone vs. jointly with spouse/decorator)

STEP 4 — WHAT ABOUT THE RE-APPROACH?

1. The "re-approach" is after you have welcomed the clients to the gallery, and they appear "antsy" so you decide to go back to give them directions (e.g., you tell them how it's laid out) — and you also told them that you would be checking back with them later.

2. You see that your client has been admiring a piece for several minutes. You re-approach with a question, not forgetting the particular power of the "alternative choice involvement" type of question.

EXAMPLES: "That's a beautiful piece, isn't it?"

"Were you thinking of something for your home or office?"

"This really appeals to you, doesn't it?

(pause for response) (Yes) — Are you familiar with the

artist? (pause for response) (No) — Would it be all right if

I told you a little bit about him/her?"

"That piece is by _____ Are you familiar with him/her?"

"Oh, I see you are admiring an Otsuka original. Do you currently have Oriental art? (pause for response) (Yes) — So are you looking for a complement to your current collection or for a unique departure?"

"What is it about this piece that caught your eye?"

"What do you like most about this piece?"

"I can see you have an eye for fine art! You must have quite a collection already to have such a discriminating eye."

"That really hits you, doesn't it?"

"Are you familiar with the state-of-the-art technology (or artist's technique, legend, inspiration, etc.) that goes into such a fine-quality limited edition print? (pause for response) (No) - Let me describe it briefly because it will surely enhance your appreciation of this beautiful piece."

(Yes) — "Well, great! What have you heard about _____ _____ that impresses you?

STEP 5 — *THE SALES PRESENTATION IS COVERED IN SECTION THREE*

STEP 6 — HOW DO YOU GET THEM INTO THE DIMMER ROOM?

1. How to get clients into the dimmer room is predicated basically on when you should direct them there.

2. In general, ask a qualifying question before you direct them into the dimmer room. (One obvious exception is when you just sense they are qualified from such clues as jewelry and clothing.) Remember, indirect questions can qualify them too (e.g., Where are you staying? — Kapalua; How long will you be here? — Six weeks).

3. Once you have established their interest, and ability to buy, then it is up to you to create the desire. You can do so most effectively in the closing room. (It's quiet, private, more "intimate," and they can get a better feel for how it's going to look in a reasonably sized room.) It is best to direct them to the closing room instead of asking them for permission to move the piece.

 EXAMPLES: (with piece in hand) "Follow me. You must see it in more natural circumstances."

 (with piece in hand) Client: "Oh, don't bother, we are just looking." Consultant: "Well, great! The best place to look at it is in here. Come on in and experience it; it's so beautiful; I want to experience it myself."

 (with piece in hand) "There are so many pieces out here; follow me so you can really get a good look at it."

 (talking as you walk) "In here we can put it on a wail where it doesn't compete with anything else."

 (with piece in hand) "Follow me; I want to show you what happens to the light bursting from behind the clouds."

 (talking as you walk) "In here it turns from soft mellow to fire and ice; just as it will in your home as the natural sunlight changes throughout the day."

STEP 7 — OVERCOME OBJECTIONS

1. Objections are your friends. They are concerns, not roadblocks. A concern can be alleviated with proper reassurance.

2. There are four parts to alleviating a concern:

 (A) Acknowledgment

 (B) Empathy

 (C) Reassurance

 (D) Confirmation

 First ACKNOWLEDGE the concern ("I appreciate how you feel..."); EMPATHIZE with the client's feelings ("I have had many clients who have expressed similar concerns..."); then REASSURE the person that the concern will be handled ("... However, when my other clients had the opportunity to experience _____, they discovered _____."). Finally, always CONFIRM that the client feels reassured. ("So, does that make you feel more comfortable?")

3. One of the best ways to alleviate concerns is to ANTICIPATE them in advance. There are only six major concerns you will ever hear, but each one can be expressed in a million different ways. Let's examine these six major concerns and possible overturns.

 SIX MAJOR CONCERNS

 - COST

 - VALUE

 - SEEKS APPROVAL

 - NEEDS TIME TO THINK

 - GALLERY INTEGRITY

 - WON'T FIT

	Objection	Yes, But
COST	"It's more than we want to spend right now." "I just bought a new house in Florida and wish to hold off with such discretionary purchases."	"I appreciate how you feel, Mr. Jones. Many of my clients have other considerations pending so that an acquisition seems less than timely. However, after we explore more comfortable financial arrangements, they are quick to take advantage of such an opportunity. May I share with you our many options?"
VALUE	"What makes this emerging artist command such a high price so soon?" "How do I know this is a good investment now?" "If the artist has already gone up in price, what makes it such a good deal now?"	"That is an excellent question, Mr. Jones ... one I had myself not long ago when I was first introduced to this artist. However, history has a way of repeating itself, and when it comes to this artist I feel confident today that his art is just as much and opportunity as it has been historically. In the last five years a similar-sized original has doubled in value. How does that make you feel?"
SEEKS APPROVAL	"I have to ask my husband." "I have to call my decorator." "Let me talk to my accountant, and I'll get back to you."	"Fantastic! Of course your_____ will need to be consulted in this important decision. I admire people who think enough of the important people in their lives to bring them in on such decisions. Why don't we go ahead and do the paperwork, though, so we can guarantee the piece is here for your consideration."

NEEDS TIME TO THINK	"I'm just not the kind of person who makes snap decisions. I always sleep on it a week or two..." "We always discuss the these purchases in detail over a period of days or weeks..."	"Of course you need time to think. I appreciate my clients who make thoughtful decisions about something that will become a part of their estate and family for generations. As you might imagine, we have a special program designed for people with your needs. Why don't we do the paperwork on it, get the piece hung over the fireplace, and then you can really feel what it will be like to have the piece. In fact, it will be yours for the first week of _____."
GALLERY INTEGRITY	"I do business only with reputable galleries in my state." "I buy art only from galleries that will buy the art back from me later." "How will I know you will even be in business in ten years?"	"I appreciate your concerns. Here you are about to decide on an important investment, and you have no prior experience with me or the gallery. Well, what if I shared that we have been in business for _____ years and have conducted business with such well-known persons as _____, _____, _____? Also, what if I provided a list of clients you may feel free to call to establish whether we operate at the absolute highest level of integrity? Would that make you feel more comfortable? Finally, I stake my reputation on it, and, with your blessing, I plan to be your art consultant for life!

| WON'T FIT | "My home's decor is traditional, not oriental."

"We are halfway around the world from home, and we're just not sure it will fit."

"What if it doesn't look like I imagine?" | "I'm so happy you brought this up. Many of our clients have expressed similar concerns. However, all of our art work is provided to you on approval. Think of it! How could we ask you to make a $20,000 investment without experiencing the piece first-hand in your own setting?" |

STEP 8 — FIND REAL OBJECTION

1. Find and overturn the real objection. The strategy I recommend to accomplish this is, after a high quality interaction (most likely in the closing room) of thirty to ninety minutes, I simply ask the client to acquire the piece (see sample SOFT closes).

2. Invariably, it will elicit the final real objection. Then, you are left to explore how to overturn the concern with: more comfortable financial arrangements, no-questions-asked return policy, proper reframing, etc.

STEP 9 — FINAL CLOSE

ASK THOSE CLOSING QUESTIONS — WITHOUT THEM YOU CAN'T MAKE SALES

1. Timing is important here also. But contrary to popular belief, timing is not critical. As long as you have a full arsenal of soft closes that you ask before a hard close, you will do fine.

 Soft Closes focus the client on owning the artwork. Soft closing questions get the client to think through how it will feel to have the painting or sculpture. Remember, a person *must own the artwork emotionally* before s/he pays for it.

 Hard Closes focus the client on paying for the art work. Hard closing questions get the client to think through specific financial arrangements that will finalize the transaction.

2. Two more important ingredients to successful closing are "opting out" and overturning objections. These are straightforward to handle, as long as you anticipate them ahead of time.

SOFT CLOSES

"So, is this something you might give serious consideration?"

"Which way are you leaning right now?"

"Were you thinking "Were you thinking of acquiring a piece of fine art symbolic of your trip here?"

"Might you get it framed or unframed?"

"If you had to decide today, what would you do?"

"Would you want us to ship it?"

"I would really like to see you have this piece; I can tell you love it, don't you?"

"How well does this fit into your living room?"

"When you acquire fine art, do you require a certificate of authenticity?"

"When you acquire fine art, do you require the gallery to frame it properly for you, or do you prefer to have your local framer do it?"

HARD CLOSES

"Since you mentioned that the total investment seems a bit of a stretch, would you consider putting a portion down on it today?"

"Would you like to pay cash or with credit card?"

"When do you require it to be delivered?"

"How should I spell the last name on the requisition?"

"If I can make the offer more attractive, then would you seriously consider it?"

"If I can make the financial arrangements more comfortable, then would you seriously consider it?"

"You say you need time to think about it. That's only natural. You're contemplating a major decision. But, tell me, when do you think you will have made a final decision?" (pause for response) Client: "Oh, in a day or two — because we'll be gone by Saturday." Consultant: "Well, I'm really excited! All I need is sixteen numbers from you to guarantee that when you make your decision, this piece is reserved."

"You say you need time to think about it. Can you tell me what you will know tomorrow that you don't know today? I want to make sure you have all the information you need."

"Why don't you go ahead and get it now, and if you change your mind, we'll arrange something?"

THREE KEY WAYS TO CLOSE

While there are volumes written on "closing tactics," I recommend three simple ways that most art consultants find easy to incorporate into their styles.

1. PROS & CONS	For the small yet distinctive percentage of the population who exhibit impatience, abruptness, and offer critical opinions: tell them it is their decision. Tell them bluntly and succinctly the many pluses and only one minor minus associated with the acquisition.
2. SUMMARY OF BENEFITS	For everyone else, I simply verbally list the pluses we have agreed upon and end with a hard closing question. (If they have a final real objection, they will articulate it now, and then I will utilize the "Boomerang.")
3. "BOOMERANG"	Once the final real objection is revealed, I ask an if...then question a "BOOMERANG" - "IF I can take care of your concern, THEN are you ready to go?"

The Key Steps — Selling Art At The Appointment

The nine key steps of selling art at the appointment will prove useful for any art consultant conducting a sales presentation at the client's home or office.

In the nineties you will find yourself doing more and more of this kind of selling. You will want to offer this service to any qualified prospect and every prior buyer. You will establish guidelines for yourself and staff as to the price points which make a home/office visit worthwhile. But before you raise the guideline arbitrarily high, think about the opportunity that exists given someone will allow you into his/her home or office.

First, if a person allows you to come to his/her home, you are immediately elevated to a place of high importance. After such a visit, that person will never "forget" who you are on a subsequent call. Second, you will get to see, first hand, how these people live and what is important to them. This is vital information you will need to make the best art recommendations. Third, you will be far more persuasive with, "This painting looks perfect over the fireplace, doesn't it?" — when, in fact, there it sits beautifully displayed in its new home. Fourth, suggesting the additional becomes a natural follow through to the initial acquisition because surely you will accept a tour to see their existing collection as well as examine areas where no artwork is displayed (don't forget about placing sculpture and miniatures). Savvy art consultants always bring an additional work of art with them on the initial site visit to facilitate the "suggesting the additional" scenario.

There are so many reasons to go to the client that I hope you will make this strategy a definite part of your company's protocol. In fact, home-based independent art dealers have been doing this successfully all along. This strategy is so effective that even resort galleries and convention city galleries can take advantage of the "at the appointment" approach as long as the dollar threshold is high enough. This is not as far fetched as it might appear. One of my clients in Honolulu had noted that a significant percentage of his prior buyers resided in California. Well, after several fruitful trips to visit his California collectors, my client decided to open a gallery there! So, if 2500 miles could be bridged, take a closer look at what distances you are contending with. There could be an opportunity waiting in your prior buyer list.

By the way, this approach has been used by many other industries. Dubbed the "puppy-dog" strategy, it plays right into the needs of the buyer. Once they get the puppy home and fall in love with it, there is little chance that they will ever want to part with it.

The nine key steps of selling art at the appointment are identical to the steps for retail selling with these exceptions: the greeting step (1), the qualifying step (2), and the dimmer room step (5). The identical steps are *not repeated* in the following text.

Step 1 — Greeting At The Appointment

Always appear cheerful and approachable regardless of the client's demeanor. Open with what feel natural. When you are at an appointment you have already made one sale (the appointment!) so relax and make the most of the time allocated. Reaffirm with the client in the first three minutes the amount of time you have available; then make certain you pace yourself so as to not run out of time. So the main points to keep

in mind with your greeting is to shake hands, verify time allowed, and reinforce rapport.

TRY "Hello, Mr. _____. Thank you for giving me a half hour of your time today in your lovely home. I'll do my best to make our time together pay off for you. (Brief Dialogue). Before we get started, how are your kids?"

"Hello, Mrs. _____. I really appreciate our meeting today. I'm truly excited about the possibility of working with you. Is an hour still good for you?" Yes — "Great, before we get started, how's the new house coming? Won't it be completed soon?" (Dialogue). No — "Oh well, would you like to reschedule? Or will 30 minutes be sufficient?"

"Well, it's so good to finally meet you in-person Mr. _____. Your wife and I have chatted about your collection, and we have talked so much on the phone that I feel as though we already know each other, don't you? (response). Well, I know you are busy so why don't we verify the amount of time we can spend today on this project? (response). Great, an hour is fine. Before we start, though, tell me about your golf tournament Saturday.."

"Hello Mr. _____, it is so good to see you. My name again is (first and last name); but feel free to call me (familiar first name). Will an hour still work for you? (response) Good. By the way, I want to compliment Mrs. _____, your executive assistant. She has been very helpful in giving me brochures about your firm so we can have a productive meeting today." (Dialogue).

Step 2 — Re-qualify At The Appointment

Ask a re-qualifying question early on in your discussions with your clients in their homes or offices. This can be very subtle and non-disruptive to the flow of the conversation as long as you ask if smoothly and confidently. The main things to keep in mind is that you already have a relationship with them, know a fair amount about their circumstances, and understand their own perceptions of their lifestyles and are ambitions. Thus, your main emphasis when requalifying is to determine timing and arrangements. The assumption here is that except for foolish or deranged people, they will not have you come all the way across town (or all the way across the country) if they are not seriously interested in the artwork you have proposed.

There are some things to watch out for, however, if you haven't smoothed out your presentation. From the mouths of unsure or less sure art consultants, the "avoid" re-qualifying questions below can be hazardous (particularly if used early in the conversation).

AVOID "Well, do you want to buy it today?"

"Why don't you go ahead and get it?" (This is a hard closing question, not a qualifying question.)

TRY "You mentioned on the phone last week that you would be making a decision on this by the end of the month. Is that still probable?"

"I sensed some urgency when we scheduled our meeting. Are you considering moving on this by the end of the week?"

"What's your timing on this?"

"We spoke on the phone a great deal about our gold-line that ranges from $_ to $_. Are you still considering this? Or can we explore the value added for our platinum line?" (This line of discussion is most appropriate for package buys by high-end residential and corporate art buyers.)

"Tell me again, what is your budget?"

"Are you considering any other options right now? Or are you pretty well convinced that we are the art source for you?"

"Were you looking for something that compliments your current collection or a unique departure? Let's take a quick look at your key pieces in your current collection, OK? That will give me an idea of what would be best to recommend now." (Collectors typically love to show you their art and to tell all the stories about each acquisition. As time permits, this is good information, but one word of caution: this can get very protracted, and you will want to be conscious of the allotted time.)

Step 3 — The Dimmer Room *Test-Drive*

How do you create a dimmer room experience at a client's home or office? The operative word here is *assertive*; you must take the lead and help the client feel comfortable with you setting up the dimmer room equivalent. It may be as simple as going ahead and hanging the painting in question right over the fireplace, after taking down whatever was already there! In other instances, you might take a portable easel for the person to view a number of options prior to hanging. The goal is to approximate the dimmer room experience as closely as possible (a quiet, private, intimate place where the client can focus, seriously consider the acquisition, and talk candidly). With this in mind, for example, an office visit might necessitate moving the discussion to an available conference room and closing the door.

TRY "I've brought so many pieces; let's hang each one, one at a time, so you can focus and experience each piece fully."

"Now that we see it over the fireplace, it is more beautiful than we imagined, isn't it?"

"Since you have some track lighting for this piece already hanging, why don't I hang the painting you are considering there so you can experience it properly lit?"

"Since you love it so well there over the fireplace, why don't I leave it here through the weekend so you and your husband can experience owning it?"

Important Underlying Concepts

There are some important underlying concepts I wish to elaborate on now that we have established as a basis for the key steps of selling art.

The Psychology Of Greeting

You're in a gallery setting. The client is walking through the door, and, more often than not, you've never seen the person before in your life.

I want to use that context because it's much easier once you've met the client before. So, let's do the cold ones first.

CONSULTANT: "Hi, how are you today?"

CLIENT: "Fine, fine. We're just looking."

CONSULTANT: "Of course, you're just looking. We've got lots of nice things to look at. I'll tell you what — I'll let you look around for a little bit, and I'll check back with you in a few minutes to see if you have any questions."

This is very different from, "If you have any questions, let me know." Do you see the difference? I can't tell you the importance of that psychologically for both you and the client. This greeting is for the people who don't want to engage immediately. On the other hand, sometimes with "Hi, how are you doing?" you can engage immediately. With those people, I'm not suggesting that you disengage. This is only for the folks who will not allow you to connect with them right from the very beginning. And that's true for a fair amount of the cold traffic that's walking into your gallery.

CONSULTANT: "Hi, how are you doing today?"

CLIENT: "Fine, fine, we're just looking."

CONSULTANT: "Of course you're just looking, we have lots of nice things for you to look at. I'll tell you what, why don't you look around a little bit. I will check back with you shortly, OK?"

It diffuses pressure. The psychology for you is so important. After a few minutes, the couple "lands" on a piece, and you just walk right back there and say, "It looks like you've fallen in love. What was it about that piece that caught your eye?"

Because you have already established a precedent for disengagement, the client feels as though s/he can simply say, "I just really want to look" — and you will allow the client to browse once again.

Further, you feel comfortable re-approaching as frequently as you like because you are allowing the client to engage when s/he feels comfortable. You give the client "space" and yet maintain control of the interaction.

Finally, don't overlook the importance of periodic re-approaches. When was the last time you found yourself in a retail setting and your first words to the salesperson were, "No, thank you, I'm just looking"? Yet, three minutes later you fell in love, and if you could not find a receptive salesperson in minutes, your buying urge was squelched, and the store lost a potential sale.

Qualify Early

I have three basic ways in which I qualify people. First of all, one rule of thumb — never, ever disqualify a person on sight. As simple as that sounds, I see people make that mistake all the time.

Number Two — never, ever rely on one or two clues to determine your qualification. Always rely on more. Now, this is where you want to pick up your clues. There are three different categories:

1. MOTIVATION PROFILE - How Motivated Are They To Buy It?

 Imagine that the person has fallen in love; he is ogling at the piece. Now, even if it's a bit of a stretch for him, he will jump through hoops if he really wants it badly enough.

 Ask the client if the art work is to be a gift or if it is for him/herself. I love this question because it elicits definitive information. The rich respond, "It's a gift," a lot more often than you might imagine. And if this $2000 graphic is a gift, just think what art they may acquire for themselves!

 The not-so-rich give you specific information about how they view their financial and art-acquisition circumstances, and that runs the gamut. For example, they may say, "I wish I could spend $2000 for a gift," or, "If I were to get it, the art work would definitely be for me."

 In either case, you have obtained insights into where to go next.

2. TRAVEL PROFILE - How Well-Traveled Are They?

 Well-traveled people are typically well-off financially and tend to relish telling others of their adventures. Obviously, if the person has circumtraveled the globe three times in twenty-four months, you will wish to probe further to determine his fine collectible habit. If art is currently a passion — bingo. If not, then you will have fun helping the client discover it. If your gallery resides in a resort town, probe to find out if the person is a part-time resident or frequents a favorite hotel. Each neighborhood, property, complex, and hotel provides clues of relative income/net worth. How frequent and long the stay will tell even more.

3. BACK-HOME PROFILE - What Do They Do Back Home?

 Does the person currently collect art, or is s/he just starting a collection? What other fine collectibles does the person delight in (e.g., jewelry, rare coins, classic cars, homes, sculpture)?

 If the person has an art collection, what does it consist of? If you are unfamiliar with the artists, be candid and admit it now. Probe further for style, investment levels, appreciation histories, credentials, and awards.

Discover what their primary residence is like (or primary residence aspiration): lot acreage, square footage, current decor, etc. Find out the person's profession and what his/her career aspirations are.

The sample qualifying questions presented earlier will give you ideas on how to probe. Just remember:

(1) Frequently paraphrase the client's input.

(2) Build on what the client has shared.

(3) Qualify the client in his/her own mind if necessary.

This last point is often overlooked. If an up-and-coming entrepreneur walks in who has every penny tied up in his/her business, help the person realize the importance of surrounding oneself with success now. Fine art can provide the emotional push for one to feel as if s/he has made it. It propels the person to ever more success.

When all is said and done, you will be able to estimate the client's net worth and/or his/her annual income. Perhaps, more important, you will be able to estimate the client's fine art buying power in the short term and thereby introduce a comfortable fine art acquisition. Because your recommendations always hit within the client's comfort zone, his/her ego is never threatened — only strengthened.

The Psychology Of The Re-approach

CONSULTANT: "Hi, how are you?"

CLIENT: "I'm just looking."

CONSULTANT: "Of course you're just looking. I'll tell you what; look around a little bit. I'll check back with you later."

CLIENT: "Nope, we're just looking; I'm sure we won't have any questions."

CONSULTANT: "No problem. I will check back with you soon. Most people come in to just enjoy the art, but once in a while they fall in love. You never know."

They look around. They fall in love. Assuming you didn't get a chance to qualify because a lot of people won't even let you engage, at that point you RE-APPROACH, "It looks like you've fallen in love." That's one of my favorite ways to re-approach. "That's really captivating, isn't it?" Now I try to use a word that's appropriate to the piece of art. "That's really colorful, isn't it?" "That's really exquisite." "That's really unusual." Whatever it is, I always follow it with that question, "Isn't it?" And then, I listen. That's a hard thing to do, you know. Most of us are so busy thinking about what we're going to say next that we don't hear what the person is sharing with us. In fact, for most art consultants all of our questions are rhetorical. It's as if we are really saying, "Just be quiet so I can talk. I want to tell you what I studied last night about this new artist. And you better listen."

Many art consultants reject the question, "That's really captivating, isn't it?" They say, "Well, what if the client says it's the ugliest thing he's ever seen?" Now, let me help you with that.

With honesty and sincerity try, "Well, you know, you're the first person that I've run across who felt that way. Just what kind of art work do you like?" Got it? So in other words, if they didn't fall in love remember, the whole purpose is to get them focused and narrowed down to something that they are in love with. Your job is not to convince them to buy something that they hate. That's not selling; that's arm-wrestling. Instead, you redirect. This happens very, very early on. I'm not talking about handling objections at this point. Handling objections refers to when the client later on has concerns. Concerns typically arise when you are in the dimmer room, and you're sitting back, and you've spent an hour with him/her elaborating on the piece. And s/he may have said, "Yes, yes, yes, yes" to many questions. That's a whole different story. S/he's not going to say at that point that it's the ugliest thing s/he's ever seen. S/he's going to say at that point things like:

"Gee, well, really, ten-thousand dollars is a lot to pay for this painting."

"I can't make a decision."

"Oh, it's just that I can't decide now. We're remodeling the house."

"I don't have a place for it."

"Oh, it's so big. It's beautiful, but..."

Yes, those are concerns, and I have already elaborated on how to handle objections. The most important thing to remember about handling concerns is to rephrase the client's words. Instead of, "I don't have a place for it," rephrase it to,

"Where can I suggest a place s/he will feel comfortable with?" By rephrasing concerns in your mind, you will respond in the most appropriate manner: with reassurance.

But what happens when you are up there? Let's say they were standing in awe and they say, "Yes" to the question, "Isn't that the most captivating thing you've ever seen?" What do you say then?

I'd say, "Let's go to a quiet place and look at it." The client interjects, "Oh, don't bother." But don't they always say that? Other times they might say, "Oh, I really hate for you to go to all that trouble." But I simply reply, "Oh, don't worry, no problem." Then I just pick it up and say, "Follow me."

The Psychology Of The Dimmer Room

I can't tell you how important the dimmer room is. I prefer to call this room or area the dimmer room instead of the closing room because psychologically it can help you to use it for its true purposes: to allow the client to focus on the art, and to speak candidly about finances and other concerns.

I have to stress that, if you don't have the space to have a nice big viewing room, then you're going to have to come up with a partition or some other compromise. You have to think in terms of making these people feel comfortable. Have them take the load off. They're not going to even tell you what their real objections are if they are concerned, for example, about being overheard by walk-bys in the main gallery.

And the traffic stops when you're selling. People mill around, and your clients become embarrassed or simply clam up. It's distracting. It's very distracting. So, you have to have some sort of private area, no matter how small and potentially cramped it might be. Otherwise you will never get out the real objections because, more often than not, the real objections can be money. And it's not going to be money per se, but arrangements. That means, even if you're talking to well-to-do people, and I've talked to many well-to-do people, they're not going to stand there where people can potentially overhear and tell you how much money they have or that they can't write you a check for twenty five thousand dollars. Quite honestly, if they've got that much money lying around in their checking account, they're not as bright as they pretend to be. They have to make arrangements. And you have to sit down with them and make the arrangements. And you say, "All right, how do you want to take care of this?" In fact, if you're really doing your job as facilitator you will say something more like, "Well, gee, did you want to just write me a check for the full amount now, or did you need to make some other arrangement?"

CLIENT: "I'd like to use credit."

CONSULTANT: "You know, I appreciate that. Why don't we put part on your gold card now. And, how did you want to take care of the balance? What do you feel is most comfortable for you? Well, I'll tell you what why don't we go ahead and put it on your gold card now, and I'll hold on to the paperwork until I get the check from you. How does that sound?"

CLIENT: "Sounds good."

Now, the client would not have responded so positively if you had not set the stage for the candid transaction. In summary, the dimmer room serves four key purposes:

(1) TEST-DRIVE - It provides an opportunity for the client to experience the artwork, visually (as I dim the light, see how the shadows deepen), emotionally (you mentioned this setting reminds you of family vacations at your grandparents' cottage), and spiritually (wouldn't it be wonderful to honor those memories with a painting that will become a treasured family heirloom?).

(2) FOCUS - By reducing distractions (visual and audio) it allows the client to provide consideration to the art work.

(3) BUILDS RAPPORT AND COMFORT - The client can share life experiences, get "close," and unwind. Serve refreshments, romance the art, and have fun.

(4) ASSURES CANDID INTERACTION - By setting the stage in this way, you virtually guarantee that every person you talk to in the dimmer room will either buy now, buy later, or tell you the honest truth as to why not ever.

So while I may sometimes refer to the dimmer room as the closing room, always keep in mind what it is really for, and you will not find yourself going for the close too soon.

What About Prices?

Do you deal with price openly? Or do you deal with it when you close? Do you deal with it early? Or do you deal with it late? People have their different viewpoints on this, and a lot depends on your style and your particular setting. But, as a general rule of thumb, I encourage people to make the price visible. Now, I know many people

disagree with me on that — I acknowledge that. By visible, I mean tastefully so. In other words, hidden behind the frame, in one consistent area on all of them. The other one is the tag that you can't see, but you have to look back a little bit, and it comes out. And everybody kind of goes for that — I know I do it — I go back and see if it's there. And you'll really like that, hopefully, because it's a qualifier: let's face it. If they're not prepared to spend twenty-five-thousand dollars, then I'd rather see them go out the door than try to sell them something for twenty-five-thousand dollars when there is not even a remote chance of their buying. So, I deal with it right up front. One of the first questions I ask is put in the context of the re-approach because that happens so frequently for you.

CONSULTANT: "That's a captivating piece, isn't it?"

CLIENT: "YES."

CONSULTANT: "What about the piece caught your eye?" They talk; you listen. "Fantastic. This particular piece is fifteen-thousand dollars. Does that feel comfortable?" or "How does that feel?" It can elicit the following:

CLIENT: "This is the first time in my life that I've bought a piece of art." (Now I know I have to educate this client on the world of fine art.)

CONSULTANT: "You know, I appreciate that. By the way, my name is Zella Jackson, and you?"

CLIENT: "Don Jones."

CONSULTANT: "Is it all right if I call you Don?"

CLIENT: "Sure."

CONSULTANT: "Great. That's all right, Don. You know, there's first time for everything. I notice you have a Mercedes. I bet the first time you signed the paperwork on a Mercedes, it was kind of tough, wasn't it?"

CLIENT: "Well, I have to have a Mercedes for my business."

CONSULTANT: "Oh, of course. I know a lot of people like yourself who have to have a Mercedes. I tell you, I wish I had to have a Mercedes. I'm just curious, Don, how do you feel about your Mercedes?"

CLIENT: "Well, it's a wonderful car."

CONSULTANT: "Spectacular, isn't it? Comfortable."

CLIENT: "I really love it."

CONSULTANT: "Do you enjoy how it makes you feel? Powerful, doesn't it?"

CLIENT: "I feel a certain sense of accomplishment."

CONSULTANT: "Absolutely. Well, you know what, Don? This piece of art work is going to do the very same thing for you. Only instead of driving around on the streets getting it dirty, it's going to be displayed exquisitely in your living room. And how much time do you spend in your living room, Don? You mentioned too that sometimes you don't even go into the office, you have so many wonderful people that you delegate work to. You like to relax and read and catch up on your paperwork right from your home. Doesn't that sound like a great way to reward yourself?"

CLIENT: "YES!"

CONSULTANT: "And you know what? That feeling you get when you drive the Mercedes will be there every time you pass that piece of art work on the wall, only even more. Do you know why? You don't need that painting, by any stretch of the imagination. You need that Mercedes to transport you from point A to point B, isn't that true? But you don't need this painting. It is truly a luxury."

CLIENT: "Well, all my friends know what a Mercedes is - but one of these — they don't know what an Andrea Smith painting is."

CONSULTANT: "Isn't that special? Isn't that special? In fact, from what you're telling me, Don, you ought to establish a nice private showing in your home and get these folks up to date! What do you think?"

CLIENT: "I want my friends to appreciate it, you know. I'm an appreciator of art. I know what I'm doing. Not only do I have

a great Mercedes, but I've got this excellent, high-quality piece of art by a lesser known artist."

CONSULTANT: "Well, you know, I get so many of my clients that express that concern, and all I can tell you is that once we get their people involved — important people in their lives what happens is, it's contagious. Their friends go for the art work as well. I'm really excited that we have decided to embark on this journey. It's going to be a wonderful relationship, and I'm sure this is just the beginning of your fine art collection of Andrea Smith. How many Mercedes have you had now over the years?"

CLIENT: "Five or six."

CONSULTANT: "Five or six; that's what I thought. Well, I am confident you'll want five or six Smith paintings, and you'll never have to trade them in. Isn't that marvelous?"

I trust this scenario with Mr. Don Jones helped to illustrate how getting the price out early aided me in being able to sell the client. I sold Don on what was important to him: prestige and luxury and I did it with an important first-time analogy. The entire discussion was provoked by his reaction to the price for a "picture," and I had to spend time qualifying Don in his own mind. Without bringing the price out early, I may never have got to Don's real concern because he would have elaborated on his accomplishments to the point where later his shock at the price would have elicited "white lies." Those of you who keep the price a secret too long, hear "white lies" a lot: "Oh, thank you very much for all that information. Do you have a card? I will call you if I decide." And, of course, they never call. The interaction is reduced to an ego struggle, and no sale will be made now or ever.

The converse holds true as well. If you get the price out early and the clients can't afford it, they are much more likely to be candid in the beginning which will allow you to effectively redirect.

CONSULTANT: "The piece you are admiring is an original oil and is only $10,000. Does that feel comfortable?"

CLIENT: "Maybe if I hit the lottery!"

CONSULTANT: "Great, well I will keep my fingers crossed because you never know about these things. Well, we do have something to fit every budget... or... Artwork starts at

$___ to $___ which gives most art admirers a chance to start their collections. Let me show you a fine quality limited serigraph by the artist you are admiring."

Getting the price out early allows you to re-direct such a client long before s/he would otherwise be embarrassed to tell you s/he could not afford the higher priced artwork.

The Psychology Of Overcoming Objections

Studies have shown that fifty percent of all salespeople do not ask for the order. What are the reasons why salespeople fail to close? That's a generic statistic, by the way. The art business is so small, there has not been a definitive statistical study. My observation, however, tells me that it is true for us as well. Why is that? Invariably this oversight is prompted by *Fear Of Rejection*.

How can we prevent this fear from paralyzing us? Well, one way to handle this is to ask yourself the following important questions: The last time you considered a large discretionary purchase and, while your salesperson was Fantastic, you decided against the purchase — did your decision have anything to do with the salesperson? The answer is No.

For example, let's assume you were shopping for a new car. Now, remember, few of us NEED a new car. Most of us trade it in before the "old" one is really used up! Right? But you thought maybe you'd like to get a new one, and you looked around, and you gave the salesperson the distinct impression that you were going to buy another car. But something else came up in your life. Meanwhile, the salesperson was right on. He was right with you. He wasn't aggressive. He was assertive, conducting himself professionally; he took you for a test-drive, asked you the right questions, and it was a perfect car for you. You told him you were going to think about it. The salesperson asked if it was OK if he called you the next day. But something came up for you. You decided not to get it. I just wish to ask, in this scenario, is there anything negative that you feel toward the salesperson? Anything? The answer has got to be NO.

Your final decision had absolutely nothing to do with the salesperson. And you've got to tell yourself this story when you need it. That's all I can tell you because I believe "no guts, no glory." If you don't ask them to buy it, I tell you, you're being very presumptuous if you're going to wait for them to whip out their wallet and throw it at you! In fact, I'm at the point now where if a person doesn't treat me professionally (and I may want the darn merchandise desperately) I won't get it because I refuse to give

him/her the commission. I refuse. I won't buy the item because I figure the salesperson hasn't earned it.

Further, self-made people — and there are a lot of them out there that have a lot of money — react exactly that way. Even people who have inherited their money respond in that way. The people they surround themselves with are like that. Do you see? You've got to put yourself out there. Whenever you overcome objections, tell yourself this little story, and you will overcome the fear of rejection.

Are there other reasons salespeople fail to ask for the order? Well, I'll tell you one more: it's lack of skill. You can call it a million different things, but a major reason why we don't ask for the order is that we don't know how. And that's why you're reading this book — to help hone your skills in that area. How can we overcome this obstacle? I've already suggested remembering the little story on Fear. The Lack of Skill problem is addressed specifically throughout the book with sample scripts and scenarios.

Buying Signals

Is there such a thing as a buying signal? "YES." What are they? Allow me to provide a context for my question. I'm imagining now that you're in the dimmer room, and you're working through some objections. You may have spent an hour with the client at that point.

1. POINT-BLANK QUESTIONS are buying signals. In fact, if a client, at that point, asks you a pointblank question, you are so close to making a sale, that you can get really excited. If you handle the interaction properly, you will make a sale.

 What is an example of a point-blank question?

 "How much does it cost?"

 "How am I going to get this home?"

 "Do you ship?"

 "Do I have to get that frame?"

 "How can I pay for this?"

 "Do you take Mastercard or Visa?"

Let's walk through an example. How can, "Do I have to get this frame?" be a buying signal? What do you say when they ask that? My knee-jerk reaction to that is to

say, "Oh, so in other words, if we can get you a frame you like — then there's nothing else that's holding you back, is there? In fact, let's forget the frame altogether. You're ready to go aren't you? Fantastic. Guess what? Congratulations, you are now the proud owner of this painting by such and such and so and so. I'm so excited for you. I'm sure we can find a frame you like, and if we don't, I've got a framer that I'm going to refer you to. We've got a big repertoire we can show you. Why don't we just start on that right now?"

Do you see the difference? Do you see what I did? I just closed the person. Now, in the event the client has a greater concern, s/he may say, "Well, no, that's not the only thing that's holding me back." Would you even need to handle that particular thing at that point? The answer is, NO.

You would handle it differently. It goes something like this:

CONSULTANT: "So, in other words, if you don't have to get this framed, then there's nothing holding you back, is there?"

CLIENT: "Well, ten-thousand dollars is still a lot of money. I don't know."

CONSULTANT: "Well, of course we can get you another frame, but the price — that's really what's holding you back then, isn't it? OK. Fantastic. I'm glad we narrowed it down. In other words, you don't feel comfortable that this artist has the value. Is that really your concern? Is it the value of the artist and the work, or are we talking about comfortable financial arrangements?"

I'm still trying to narrow it down. Price resistance is not the same in all cases, isn't that true? I could talk for twenty minutes about the value and the credentials of the artist, et cetera, where s/he is exhibited and so on — and be off the mark. I could talk all day long about financial arrangements, but money is no object. You see? Narrow it down because the client will tell you.

CLIENT: "Well, oh shoot, money's no object if I — I just never heard of this artist before. Andrea Smith, right?"

CONSULTANT: "Oh, so, in other words, the ten-thousand dollars — that's no problem — you're just concerned because you've never heard of Andrea Smith, and I've just not done a good enough job here elaborating about her credentials and her emergence into the art world, and that sort of thing. I'm

just curious, we've already spent an hour, and I've shared a lot of things with you. I've shown you some things in writing regarding her exhibitions, awards, and collectors. I'm just curious, what will it take to convince you?"

Isn't that hot? And the client will tell you. Then you will be able to respond to the client's specific concerns.

2. OBJECTIONS ARE BUYING SIGNALS. Objections are your friends. I'm really suspicious of a person who doesn't have a concern because, without concerns, the people are not potential buyers. The absence of concerns to me says they're not qualified in some way (money, interest, etc.). Without concerns you are most likely talking to someone who is "just looking" and s/he is just putting you on. I am very suspicious when I'm in the closing room and I'm going through the final stages, and the person is passive.

By and large, if the person is connecting with the art, building rapport with me, etc., then s/he is seriously considering the art work. However, invariably a legitimate concern will surface that I want to address. If I don't address the concern, the client will be unable to make a final decision. I want to pull out the concerns, you see? It's important. They're your friends. They're concerns, not roadblocks, and the important thing here is the concept that you want to provide reassurance.

Remember, acknowledge the concern.

CONSULTANT: "So, in other words, Mr. Collector, if I understand you correctly, you feel like I haven't given you enough information about the credentials of the artist. Is that correct?"

CLIENT: "Yeah, that's it..

CONSULTANT: "Let me give you some more information about it — maybe I could show you something in writing — you know I have something in my files that I want to show you. I'm going to describe it to you right now, and we'll take a look at that in just a moment. If you are convinced that the artist has the credentials, et cetera, that you are looking for, then you're ready to go, is that correct? Great, well, I'm really excited."

Sometimes at that point I'll still say, "Congratulations! You're the proud owner of this beautiful Andrea Smith painting because I have no doubt that I'm going to be

able to provide you with the information you need." And I look for the client's reaction at that point. Then you go through the overturn — and the basic concept of the overturn is YES, BUT. One footnote here, though. Never, ever — and there are very few nevers in this world, but here's one of them — never, ever disagree point—blank with a client — even if s/he says, "Oh, that's a beautiful green!" and you think it's blue. You will want to say, "Oh, you see green, huh?" Never, ever disagree point-blank with a client. You agree, so to speak, first, and I'm not suggesting you lie. What I'm suggesting here is that you have to have an appreciation of other people's styles. This is where you have to live it out. If you can't honestly and sincerely say, "I appreciate how you feel," then you're in the wrong business, or you need some more growing up to do. You have to be able to say that with all genuine sincerity "I appreciate where you're coming from, however..." That's the overall concept.

Now, the three F's are a little handy technique that you may have heard of before. It's a standard tip in the sales field. The three F's give you a mental picture or framework that you can draw upon. You don't want to use the exact words, but these are the elements. "I know how you FEEL. I've FELT that way myself, but let me tell you what I've FOUND."

It has the empathetic part, and then it has the overturn the "however, let me tell you what happened." Now, I'm not suggesting you lie. If you don't feel that way, then you say something like this:

> "You know I can appreciate how you feel. A lot of my clients have expressed that concern in the past, but can I share with you what they discovered? As a matter of fact, when this particular piece was framed in black lacquer, they loved it. We don't have anything right now that's framed quite that way. We just had one, and it sold so quickly off the walls. I'm sure if you had seen this piece that way, you would have loved it! And then it would go beautifully with your Japanese decor. Can't you just see that?"

Another reminder: Always ask how the client feels about the empathetic story you've just shared. Many art consultants make the mistake of rambling on and on, and they never find out if their FEEL, FELT, FOUND story hit home because, again, they're afraid of the reaction in which the client says, "No, I'm not convinced." You've got to find out; otherwise everything you say from that point on will not be heard. You've got to believe me on this. So you want to say:

CONSULTANT: "Well, then, does that make you feel more comfortable?"

CLIENT: "Well, not really."

Then you've got to do it again and again and again.

CONSULTANT: "Well, does that make you feel a little more comfortable?"

CLIENT: "Yeah."

CONSULTANT: "Fantastic. Well, I tell you what I'm going to do the paperwork on this, OK?"

If you don't feel like you're ready for a hard close, then you give them a soft close at that point.

CONSULTANT: "You say you feel a lot more comfortable. Gee, is this something then that you're starting to feel will look exquisite over the fireplace?"

CLIENT: "Yes, it is."

CONSULTANT: "Well, why don't we go ahead and do the paperwork on this?" (I do a one-two punch if I'm not sure —a soft close, then a hard close.)

More on closes later. For now, let's examine the underlying psychology of handling objections.

The Six Objections

What holds the client back? COST, VALUE, TIME TO THINK, WON'T FIT, GALLERY INTEGRITY, and SEEKS APPROVAL.

Everything, when you stop and think about it, fits into one of these categories in a broad way. Now, the power comes in anticipating the objections because, instead of having this tightening in your stomach when they throw the objections out, you'll start to grin. I know I do. You start to grin, and you say things very sincerely and honestly. "I just had a feeling that was on your mind." You feel like you've heard it all before it's deja vu. And so if you spend some time and energy thinking of how to overturn each one of these, then you'll feel the same way. Now I'll give you my words for each one of these. You find your own words — and then you've got it.

Cost

This is the easiest one. First of all, let me just say that many art consultants misinterpret and think that cost is the only objection, and they interject it and project it onto the client. Don't do that. Quite often cost is the last thing on the client's mind. You should be able to evaluate that very specifically if you've qualified the client appropriately. Remember, I said that the final close is very straightforward and easy, but it's predicated on doing everything right up to the point of closing. And if you blow it on cost, then you probably didn't qualify the client properly. It's not that you didn't overturn the objection well. There is a very important distinction. You've got to know where to put your emphasis. You're making mistakes out there, and it doesn't do you any good. Here's an example that I see happen time and time again. It goes like this. You go through the whole nine yards. You didn't qualify him properly. Here you are, and the person is in love with a ten-thousand-dollar piece. All he can afford to spend is two-thousand dollars. You have yet to tell him even how much it costs. You're an hour and a half into it. I've seen it happen. Then he asks you. Boy, when he asks you how much it costs, you've blown it.

If he says, "By the way, how much is this?" and more than five minutes have gone by you have blown it. "Oh, this particular piece is ten-thousand dollars." (And you say, oh, I'm supposed to ask, "How does that feel?") "How does that feel?" And in the context of an hour and a half into the interaction, I'm telling you, even at this shock, he's going to disguise his response. You're not dealing with the real people. You're dealing with people who have to pretend, and they're going to "lie" to you to escape embarrassment. Most likely, you'll never see those people again. In fact, you're going to get an excuse that's not even real — that is not candid — that you cannot overturn because there's no way in the world that they can write you a check for ten-thousand dollars. Do you see?

And they say, "Oh, Ah, Hmm." And then you can write that on the back of your card. "Thank you so much, you've been so helpful. I'll call you and let you know."

Now, if you had qualified them early on, you wouldn't be spending an hour and a half in the closing room on a ten-thousand-dollar piece for which you know they can spend only two-thousand dollars. You would have quickly redirected them to a two-thousand-dollar piece, and you would have had that in the room with them. And then the issue of cost, if it came up, would be the genuine concern that you could overturn. Do you see? I have to elaborate on that because people say, "It's always cost; you get them in there, and they love it." In fact, the art consultants say, "I know they loved it. I can't understand why they didn't buy it." Gee whiz, if you don't have the money, you don't have the money. You can't create it. So if it's a genuine cost concern, it goes like this:

CLIENT:	"Well, you know, to be quite honest with you, I'd be hard pressed to write a check for ten thousand right this minute."
CONSULTANT:	"Ah, so in other words, if we can make the financial arrangements more comfortable for you, then there's nothing else holding you back?"
CLIENT:	"Yes, ma'am."
CONSULTANT:	"Well, how much would you feel comfortable putting down on it today?"
CLIENT:	"Could I put down $5000?"
CONSULTANT:	"Fantastic! Of course — thank you, sir. You are now the proud owner of And how much time will you need to take care of the balance?"
CLIENT:	"Until the end of next month."
CONSULTANT:	"Great!"

I suggest asking the client, "What do you feel comfortable with providing me today?" Many art consultants prefer to say instead, "Let me tell you about our layaway plan." And out of everything, you get a minimum of ten-percent down. Don't do that. Ask them, "What would you feel comfortable providing today?" Many times you will end up with a two-week layaway instead of the six-month plan that might be canceled on you.

I just wish to reassure you that most people don't want to say too small a figure. They put themselves under pressure and give as large a figure as possible. I'd say most of the time they tell me a figure that amounts to one-half of the retail price. If you get half from a person that day, the chances of cancellation are very slim. In another example, it may go like the following:

CONSULTANT: "Well, how much would you feel comfortable putting down today?"

CLIENT: "Fifty percent."

CONSULTANT: "Fantastic. How did you want to take care of the balance?"

CLIENT: "Oh, gee, when I get back home, I'll write you a check next week."

Fantastic. Now, if I had told the client about my layaway plan, I would have got ten percent of whatever the minimum was that management told me to tell people, and it would have been strung out for six months, and the likelihood of cancellation would be very high.

Several of my students ask at this point, "What if they say they really want it, but they don't offer the minimum? You need a minimum for layaway. You need strict procedures to follow to do the paperwork."

Yes, this is true. But, don't misunderstand my point. When you ask people that question and try to get a definitive response from them, my main point is that, more often than not, they will come back with more, much more, than the minimum. And I really want to discourage you from giving them a little lecture on your layaway plan. If, on the oddball chance you get somebody that hits you low — s/he gives you a figure that's nine percent and you need twenty-five — then all you do is bring him/her right back up. You still don't tell them, "Well, our minimum, our absolute minimum is twenty-five? You don't talk about our layaway plans. You say, "You know, I really appreciate that offer. I really do. And I know you want this piece. I want to see you have this piece because you love it so much." I then thoughtfully say, "I'll tell you what. (Then I throw out what the minimum figure is.) If you can make it such and such, then we've got an agreement." And they usually say, "Oh, OK."

Some of my clients often feel compelled to "nail down" the minimum deposit policy so art consultants don't mistakenly accept token deposits from unqualified clients. I encourage the flexibility of my earlier scenario. Art consultants, trained properly, use their training to everyone's advantage.

Value

Now, let's talk about value. This one's probably the toughest and the one that you have to do a lot of Feel, Felt, Found stories on, and it's predicated on how well you delivered your sales presentation. This is the one that I always anticipate if I'm talking about an emerging artist or if they have never heard of this person before, even if the person is, in fact, established. Remember, you have to strategize and do things up front in anticipation of what their concerns will be. If they tell you in the first fifteen minutes, "You know, I have never heard of them," then you want to ask, "Are you familiar with the artist?" Client: "No, I'm not." Then, you may even have to spend a fair amount of time elaborating on the artist's background. One Caution: Never use ESP.

Have any of you readers ever earned your living from exercising your ESP power? Anybody? Don't get me wrong. I believe in being intuitive. I feel I'm pretty intuitive, but I don't guess with clients. I ask. Just say, "You mentioned you'd never heard of this artist. Would you like me to tell you a little bit about her background and training and that sort of thing?" Only if they respond, "Oh, yes," do you load them up with that. But, because they told me that way up in front, I'm already going to anticipate that, when I ask them to buy, it's going to hold them back. When I say, "What's holding you back?" they're going to say, "I'm just not sure if I should go ahead and get something like this when I've never heard of the artist." You can bet on it. If I were a betting person, I would bet that it's more than fifty/fifty; so be prepared, and say, "You know, funny you should mention that. I had a feeling you were going to say that. Well, let me share with you that I mentioned a lot of things about where she's exhibited and her collegiate training, and who collects her. I'm just curious, what will it take to convince you?" That's one important question I ask. The second thing I'll ask: "Well, you know I mentioned all these things, and so on. I'm just curious, what about the artists that you currently collect convinced you to go ahead and get started with them?" And whatever they say — bingo — you throw it right back on that particular artist. Do you see how that works?

Time to Think

This is an easy objection to overturn when you really get down to it. First of all, let me just say that the majority of the population has a genuine need to think about it. You have to really expect that and appreciate that. Now, if you've done all of the things right to begin with, then you have read them properly. We're going to study "people reading" more thoroughly later in Section 3, so you can get some further verification on what kinds of people require this. I'm at the point now where, as soon as they walk into the gallery, I think, "Here's a deliberator. I've got to do a one-two punch. Maybe a one-

two-three punch." Strategy, strategy. So, Number One, I never give them everything the first time out. I anticipate right away and, sure enough, an hour and a half into it I say:

CONSULTANT: "Why don't we go ahead and do the paperwork on this?"

CLIENT: "Well, you know, Zella, we're just not the kind of people to make a snap decision."

CONSULTANT: "You know, I kind of anticipated that. You folks seem like that."

I lower my voice for these soft-spoken people. And they're usually dressed conservatively. They walk quietly, and they don't talk much. I say:

CONSULTANT: "Do you know what? I really admire people that make thoughtful decisions. I wish I were more like that myself. (As I get older I sure am getting more like that.) I'm just curious, which way are you leaning right now?"

CLIENT: "Oh, shoot, if we had to make a decision right now, no question."

Boom, I know they're going to buy it.

CONSULTANT: "Fantastic. How much time do you need? How long will it be before you make your final decision?"

A lot of times they go blank on me, so I have to facilitate that. I say:

CONSULTANT: "By the end of the week? The weekend?"

CLIENT: "Yeah. Monday, let's say Monday."

CONSULTANT: "Monday, well, fantastic. Many people like yourself come to the gallery with that concern. We have a special program designed just for people like you. Why don't we go ahead and do the paperwork on it? I won't cash your check, and we'll hold onto it until you let me know on Monday. Would you want me to call you, or do you want to call in? What is comfortable for you?"

Whatever phone appointment or arrangements you make, you'd better be there. If they tell you they are going to call you at nine o'clock on Monday morning, they're going to be sitting by the phone at fifteen minutes till. And you'd better be at that phone when they call you. Otherwise, you can forget it if they're a first-time client of yours.

Now, many times they'll say, "No, no, I don't feel comfortable with that."

CONSULTANT: "You know, I appreciate that, I tell you what, why don't we put a small something down on it right now? That way we can hold it for you until Monday. No problem."

CLIENT: "Well, no, no."

CONSULTANT: "You know, I appreciate that. Well, why don't we set it aside for you? You know, I trust you so much (and again, this is with the higher-end things that I'll do this), and you folks trust me, don't you?"

CLIENT: "Yes."

CONSULTANT: "I'm going to put your name on this piece and take it off the wall because I'm so afraid that it's going to be sold otherwise."

And if you've read this kind of people right, and if you've done your homework up front, they will not let you down. Got it? I've done that. In fact, at one of my galleries I shared this technique with the art consultants as a team, and one of the ladies took it one step further. She said:

CONSULTANT: "You know, I know you want this piece (we're talking about a thirteen-thousand-dollar painting) so badly. I'll tell you what, I'm going to take my gold card; I'm going to go ahead and print my own card for you."

CLIENT: "No, no, I don't want you to do that."

CONSULTANT: "I want to do this for you."

And I want you to know that woman, that art consultant, sold those people a ton of art work. So I've given you some ideas on that. Now, remember maybe it's appropriate for me to say this now if I haven't said it already — nothing will work one-hundred percent of the time. Nothing. I'm not a magician, and are any of you out there magicians? You can't arm-wrestle people to the ground to get their wallets. But, if you use these techniques faithfully and strategically, I can guarantee that you're going to sell a lot more art work than you've ever sold in the past. That I can guarantee you!

Many of my students ask at this point, "Based on your experience, when people say they need time and you give them time, what percentage of occasions do you get

that kind of commitment? Or do most people still leave without really making a tangible commitment?"

First of all, sixty percent of the population, in my mind, have a genuine need to think and deliberate, and there are all kinds of studies I can share with you on that. Of that group of people, assuming that they've connected with the piece emotionally and spiritually and that you've qualified them, about anywhere from thirty to fifty percent of them will commit. Now sometimes they'll cancel on you. But, in terms of that moment, that day they'll think about it and decide for or against it. You have to be prepared for when it's against. But, that's OK too because, to me, you're going to sell the client something in the future. The important thing is that you want to be their consultant for life.

Won't Fit

The client says, "It won't fit." What do you say? "Take it home on approval." That's the easiest thing — on approval. But what if they bring it back because it doesn't fit? Well, you take it back! And find something else that does fit.

Remember you are dealing with the New Market. Their expectations are high. The New Market has been trained by very sophisticated merchandisers. Why, they have had the experience of previewing thirty-dollar items with a full-satisfaction, money-back guarantee (within thirty days).

How often does the client return a piece? Remember, you save this for your high-end art work, first of all. Second, I want to provide some perspective because, in our experience — I mean the many hundreds of art consultants I live through vicariously here — I'd say ninety percent of the time, once the clients take it home, it's theirs.

It's theirs. Why? (This is more relevant to people who get things shipped.) You get this big crate, that's been handmade, and it's a monster. I had that experience myself. I bought a Rebecca Holland several months ago, and I had a place for it picked out. This monster of a crate came, and my husband and I tore it apart. Now remember, the crate was destroyed. There was this huge Rebecca Holland painting that was too big for where I wanted to put it — and Larry and I looked at each other. We spent the rest of the afternoon rearranging our art work — and we found a place for that Rebecca Holland painting, let me tell you. I wasn't going to send it back. So, unless your clients are very, very well-to-do, they're not going to send it back — and even if your gallery is in the neighborhood, once they live with it, they're not going to bring it back, statistically speaking.

Another thing I've often found is that if clients are planning to acquire a painting, and that painting doesn't work out for them, they're still in the market for a painting. And I'm going to find out what else they may wish to consider at the time.

Last, if you say, "Sure, we can take that back, no problem," they're going to come back. Remember, be their art consultant for life.

Gallery Integrity

Unfortunately, this issue has become a legitimate concern for art collectors. A lot of bad publicity has emerged in the aftermath of fraudulent art dealings in major art centers in throughout the country. Further, this concern is particularly strong when art buyers are traveling and are unfamiliar with the gallery.

Here in Hawaii, we have had to deal with this for years because of one large art gallery chain that was twice featured on a "60 Minutes" expose and the subject of negative stories in the *Honolulu Advertiser* during a two year period. Further, the majority of the art buyers in Hawaii are here on vacation. I think it is fair to say that those firms still in the art industry in Hawaii today have gotten pretty good at handling the "Gallery Integrity" objection.

The main thrust to successfully handle this objection is to distinguish your firm from others in the area experiencing bad publicity. Also, make sure your art firm does community service (e.g. donates art to worthy charities, etc.), the owners are environmentally sensitive, and you provide a minimum of a 30 day money-back guarantee. In addition, an active PR campaign should ensure some positive press you can include and point to in your portfolio. Lastly, you should provide prospects photos of prominent clients with the artist/artwork. Similarly, lists of recognizable names help (celebrities, political figures, physicians, and C.E.O.'s). With this arsenal of positive information, it is straightforward to construct several Feel, Felt, and Found stories to reassure the client.

Client: "I don't like to buy art from galleries I'm unfamiliar with."

Consultant: "I fully understand your concern. Many collectors have a favorite art dealer they do business with. Is that your tendency? Or is there something else on your mind?"

Client: "Well, frankly, I have heard so much bad publicity about fraudulent (artist's name)that I am concerned."

Consultant: "Thank you, for being so candid. I really appreciate your concern. And I am glad you came to us because our reputation

is impeccable. Here, look at my portfolio.... you will see the owner with the Governor of our state at a _____ Art Festival; here are some of the people who are collectors with us (show photos and lists of recognizable names); etc. After fifteen years, our reputation remains flawless. Does this information help to reassure you?"

Client: "Well, yes it does."

Consultant: "Great, because with your blessing, I want this to be the beginning of a life-long win/win relationship."

Seeks Approval

What if the client says, "I've got to get my decorator involved," or, "I've got to bring my wife"? Let me start by saying that, when you qualify people, part of the qualification includes the fact that if a person walks in alone and is wearing a wedding ring — you ought to have a knee-jerk reaction that goes like this: "You know, I'm just curious, if we were fortunate enough today to find something that you really loved, do we have to, perhaps, get your spouse involved?" It's the same with your overall strategy: Gee, do I want to give them everything now? If you go through the whole rigmarole, and you will get nothing and have nothing left to share with the decision-maker, then save it. What you want to do is "sell" the subsequent appointment that is required to get them excited enough to seriously consider a purchase. You must have both of them together if a decision is to be made. Remember, the other part of that strategy is to determine with them both in the room who is the final decision-maker.

Oftentimes I allow a lot of confusion to go on at first; they go back and forth, and I sit back and watch. Then I say, "You know what? It sounds to me like you folks are confused. Who is the painting for, anyway?"

CLIENT: "Well, gee, honey, I just got that bracelet. It's for you, really, I mean, you're the one who saw it originally."

CONSULTANT: "Fantastic, so this is your painting. All right."

Do you see? You facilitate the decision-making.

How Do You Gracefully Determine The Decision-Maker?

What happens when you get the husband and wife together, and they bicker back and forth in total confusion? First recognize this is natural. So, what I usually do is stand

back for a minute or two and then go through it. In fact, they need my help, and they know it. I step in and say:

CONSULTANT: "You know, I can tell that you people are confused."

CLIENT: "Yeah?'

CONSULTANT: "Can I make a suggestion? Number One, is this particular piece going to be for you, ma'am, or for you, sir?"

If they draw a blank or are confused, I say, "You mentioned earlier that you recently redecorated the family room, and that was your project, right? I tell you what, sir, why don't we go ahead and call this yours. You're the one who came in originally, fell in love with it, and bottom line you never want to compromise in your fine art acquisitions because then every piece is lukewarm. You've got to stick with your personal conviction — and that rests with you, sir, doesn't it? Fantastic. I mean, the only reason why you wanted your wife to come in really was that you wanted to make sure that she enjoyed it sufficiently, but bottom line — this is your piece, isn't it? Great."

The other thing I do is start elaborating on a Feel, Felt, Found story and say: "Have you ever had the experience of compromising on a fine collectible?"

Many times they have and say, "Oh, yeah, remember we were trying to figure out what silver we should get? Neither one of us loves the pattern we got because we were trying to please each other. You know, I should have let you choose." (A real client said this to me.) "I should have picked the silver, and you should have picked the china pattern." They have these revelations. "We're going to do this from now on take turns."

You may want to get the person you initially dealt with to stretch and make the decision on his/her own (without the mate present at a subsequent meeting).

"Why don't you go ahead and get this piece on your own; you deserve to treat yourself once in a while. Don't you? This can be a memento of your trip. This is for you."

As a fall-back, if it turns out that the husband just can't handle it, don't worry about it. In the end, we'll make arrangements. I never say, "We'll give you your money back"; rather, "We'll make other arrangements." In other words, we'll get them another piece, and they never send it back. Many times they'll say, "Oh, OK."

Remember, the wife (in this case) really wants you to reassure her that it's OK to make the decision. I'll say:

CONSULTANT: "I'm just curious, has your husband ever made a decision on behalf of the two of you without your being there?"

And she inevitably says, "Yes."

CONSULTANT: "I'm just curious, if it was something personal for him, that made him happy, how did it make you feel?"

CLIENT: "Oh, I was happy for him."

CONSULTANT: "You know what, I bet you that's how he's going to feel for you."

The Psychology Of Closing

Many of my students feel that "closing" is their weakest skill. In fact, those of us who wish to dramatically increase our sales would best be served by looking elsewhere in the selling process: lack of rapport, failure to qualify, failure to set the stage for a candid interaction (e.g., in the dimmer room), and failure to overcome concerns are all more likely areas of deficiency. After all, it is far more difficult to properly set the stage than it is to ask a simple question, "How would you like to take care of this, cash-check-or-goldcard?"!!! Perhaps one handy way to soften this inevitable question is to effectively use soft closes.

What's A Soft Close?

A soft close is assumptive, nonthreatening, and indirect. In general, any question that focuses the person's decision-making on having and owning the art is a soft close. In other words, "Oh, how do you think this is going to fit over the fireplace?" This is after you've got all kinds of oohs and ahs. You're already anticipating that they're going to say something like that. So you facilitate them to do just that.

CONSULTANT: "Is that right? You know you mentioned this and that. It sounds like you like the frame?"

CLIENT: "Oh, yeah, it's perfect."

Go right for the hard close.

CONSULTANT: "Why don't we go ahead and do the paperwork?"

That's one strategy. It's a simple one-two punch.

What's A Hard Close?

Let me just say that a hard close, to differentiate from a soft close, focuses on the transaction — the dollars. "Would you like to go ahead and do the paperwork on this?" "How would you like to take care of this?" "Would you like to pay cash, or with credit?" "How shall I spell the last name on the requisition?" The transaction the paperwork.

What about encouraging the clients to take a piece on approval? Absolutely. Everything is based on approval, anyway, isn't it? Is that a soft or hard close? Make no mistake, that's a final close. I'd say it's a hard close. If they make a decision on that, then they're going to take the piece. My observations indicate that once the person takes it home, s/he keeps it.

And they know that. In fact, we even encourage it for real high-end things. It goes like this:

CONSULTANT: "Well, what's your real concern?"

CLIENT: "Well, I'm just not sure if it's going to work." (This happens particularly in resort towns; they're so far away from home.)

The size is somewhat elusive to them; will the piece really work? I reassure them:

CONSULTANT: "You know what? I appreciate that. Do you know how many people come through here who have that same concern? I can't tell you! We have a special program for people just like you. Why don't I go ahead and send it out to you? You live with it for a week. That's the only way you're going to really tell anyway. Size considerations aside, how are you going to know that the colors and the feeling in your home are exactly what you're anticipating? Why don't we go ahead and do that then, OK?" Now this, of course, is for a very high-end piece.

Three Key Ways To Close

There are three key ways to close. Now, there are books written on closes. I have one in my office, but I've never read the whole thing. It's an inch thick all on closes. And I find many of them are very manipulatively worded and condescending to the New Market. Let's face it, you can't "trick" a person into buying fine art. And if you do, you will get substantial cancellations and no repeat business or referrals. What good is that? I don't suggest to my art consultants that they get complicated at closes because if they've done everything right up to that point, the close is the simplest aspect of it. It really is. There are three simple ways to close that I encourage.

Summary of the Benefits

Number One is a summary of the benefits, and that's the easiest one for most people. "So, let me see here.... (Remember, we're in the context now.) Now, we've spent an hour and a half here. You've been absorbing this piece. It's size is like you're anticipating, and the color is perfect. And that composition is so compelling for you. You just love the way the center of attention is drawn to the light behind the clouds, and when the light changes, it just, whew! This is the piece for you. I'll tell you what — why don't we go ahead and do the paperwork?"

In your summary of benefits, you mention or paraphrase all the things that they mentioned to you or agreed with you that they loved about the piece. Now, I've found this will often elicit the final objection. They say, "Well, oh, darn, I do love it, and you're right about all those things and blah-blah-blah, and I did say that and I did say this, but..."

CONSULTANT: "Well what is it? What's holding you back?"

This is why privacy is so important. This is why that whole thing of having a space to have them talk and be candid with you is so vital.

CLIENT: "Well, I must say, it'd be hard for us to write you a check today for twenty-five-thousand dollars."

CONSULTANT: "So, in other words, if we could make the financial arrangements more comfortable for you, there's nothing else holding you back, is there?"

The *Boomerang*

The second way to close is what I call a "Boomerang." If — then. Anticipate it. And that will work for any of you. I use the price in this example because everyone thinks that price is the issue, but more often than not, it isn't. It's usually something else, and if it's the price, it's usually the financial arrangements, not the price. Remember that price can never be the issue if you have qualified the client earlier on in the interaction.

EXAMPLES — Consultant: "If we can get you another frame, then there's nothing that's holding you back?" or "If I give you some more information about that artist that will convince you that the credentials are there and the value is there, then there's nothing else holding you back?" If— then, if — then, see how that works? It's powerful. I usually do a Summary of the Benefits, fully anticipating the final objections, and then I wrestle the final objection to the ground — because anything can be worked out, can't it? Now, the thing I want you to be aware of here is that when you do act, you have to

think ahead of time how you're going to take care of it for them. It's got to be easy; it's got to be smooth. You've got to know the financial arrangements that you're willing to accept.

The third way to close is one that we're going to talk more about later that deals with personalities and styles.

Pros and Cons

This close is the one for those very direct personalities many times the corporate clients are this way. As a matter of fact, a lot of the self-made entrepreneurial types can be so bottom-line that it's borderline rude. That is how we sometimes react to it. With those people, I use a variation on the Benjamin Franklin close which is the Pros and Cons approach. It goes like this:

CONSULTANT: "Well, Mister Very-direct-entrepreneurial-person, you're a very busy person."

CLIENT: "Yes, I am."

CONSULTANT: "Time is money. I know you want to make a very quick decision."

CLIENT: "Yes I do. I don't beat around the bush."

CONSULTANT: "Well, it sounds to me like the size is correct. We've got a repertoire of things that you can select from. I think we can work out a budget. All these things we've agreed on. And, in fact, your only concern that I can remember is matching up the right frames with the right pieces. I think we worked that one out, didn't we? It's really your decision. I don't know, many more things are going for this decision than against it. It's your decision."

In other words, you lay it back to them because they have a negative knee-jerk reaction to anyone telling them what to do. Do you see how that works?

Recapping The Selling Process

I want to quickly recap the Key Steps of Selling Fine Art in the gallery. I think this will reinforce everything you have read thus far.

GREET

When you greet just remember — one of the most important things to do is to stay in control. I always appear approachable and cheerful even if the other person is looking rude and defensive.

Remember that with your greeting, the key thing is that it has to be in your own words. I never suggest that you memorize the sample scripts. But, stay in control — always appear approachable and cheerful. "I will check back with you later," is something that I have found is very effective for me psychologically, and it also helps to set the stage for the client. "Let me tell you how it's laid out." That's the gallery tour. If you want to try to engage in conversation, enlist them early on. Some of them will go ahead and start talking with you right away. This is an excellent way to get them involved.

QUALIFY

When you qualify, one of the key things to remember is to qualify early. One of the biggest mistakes my novice art consultants make is that they waste a lot of time on the wrong people. On the other hand, don't disqualify on one or two clues. Try to get as many clues as you can. Remember, the way people are dressed is not enough. They tell you they've never acquired fine art before. That's not enough. How many times have you made a big sale to someone who told you that s/he had only posters? It happens. Ask them about how much they're in love with it. Remember, if they're in love with it, they'll bend over backwards to get it.

LISTEN

What is the average person's listening efficiency? "Eleven percent." Never forget that you are retaining only eleven percent, and so are the clients. Remember, the way you increase it is to get them "involved." And don't forget the test-drive, the questions and the note-taking. Also, Shut up! That's one of the most important ingredients of listening effectively. When you stop and think about it, you must concentrate. It's difficult to listen and assist your client to do the same. Remember, you can tell them, "Write this down." And they do, don't they? We'll elaborate on the sales presentation in Section 3. I have glossed over it thus far because I have a whole section on it.

RE-APPROACH

As far as the re-approach goes, remember, one of the best ways to re-approach is to ask a question. Remember we talked about speaking opinions? Don't be afraid to

say, "That's really captivating, isn't it?" And so what if they say it's the ugliest thing they've ever seen? What did we say?

CONSULTANT: "Well, you are the first person to react this way about this piece. I'm just curious. What kind of ark work do you like?"

This is not about overturning an objection at this point; it's time to RE-DIRECT.

Another way to get them involved is, of course, to use the old alternative-choice involvement question.

CONSULTANT: "I'm just curious, do you already collect fine art, or were you thinking about starting a collection? Were you thinking of something for your home or something for your office? Were you thinking of (this is one I like to ask, especially when you're looking at something that costs thirty-thousand dollars) something for yourself, or is this going to be a gift?" I love it because the rich people don't even blink an eye. I love it when I get that one out of a hundred - people who don't even blink an eye. They say, "Well, as a matter of fact, this would be perfect for my daughter." This is wonderful. I tell you, you'll be surprised. Their "play money budget" just happens to be a lot bigger than ours.

DIMMER ROOM

For the dimmer room, we want to remember, just pick the piece up. I tell you, you should pick it up in minutes. Of course, they always object. What do they say:

CLIENT: "Don't bother."

CONSULTANT: "No bother. No trouble at all. Come this way."

What do they do? Follow you. They will follow.

OVERCOMING OBJECTIONS

When you're handling objections, remember, objections are your friends. In fact, if you don't hear these objections, you're talking to someone who's shamming you. And they're looking at you, trying to pretend that they're rich. Or worse, you have to do either a lot of educating or something else you are missing. If they don't have any

73.

objections, that's when I get worried. The important thing is to anticipate the objections because there are only so many when all is said and done. All the possible objections you will ever get fit into six categories. Remember, objections are concerns. All you have to do is provide reassurance.

FIND REAL OBJECTIONS

When you're trying to find their real objection, one of the things you can ask them is, "Do you want to go ahead and do the paperwork?" If they hedge, simply ask, "Why not? What's holding you back?" You want to find out what it is. Then you can overturn it because anything can be arranged. Isn't that true? Anything. Don't be afraid to ask them these things. There are many ways to say, "Why not?" I don't mean that you should start stampeding people and say, "Well, why won't you buy it?" But you can ask very sincerely and genuinely, "You know, I'm really curious. We've spent quite a bit of time here, and you've been so excited and interested. I can't imagine why you would want to deny yourself this opportunity." You can say that if it's comfortable for you.

CONSULTANT: "What's holding you back? Because I really want to see you have this. I know you love it. Can you imagine life without it now?"

FINAL CLOSE

Remember, don't be part of the fifty percent of the art consultants out there who don't even ask their clients to buy the piece. ASK THEM. What do you have to lose? Absolutely nothing!!! And don't fool around with manipulative closes. Just ask them straight out to buy it!

SECTION TWO — SPECIFIC SELLING STRATEGIES

In this section I wish to elaborate on specific aspects of the selling process in overall strategies you may wish to employ.

Selling Art As An Investment

First of all, I'd like to reinforce the notion that it's probably not a great idea to stress the investment value of art. There are two basic schools of thought on it. There are galleries that have as their whole marketing approach the concept of art as investment. In fact, some of them are being investigated by the SEC right now, so what can I say? Very simply, I discourage that. And if you talk about investment at all — or, in particular, if they bring it up, then I say something like:

"You know, I really appreciate what you're saying. You want to make sure that what you're putting your money into is something that has staying power. You don't want this artist to be a flash in the pan. That's really your concern, isn't it?" Then I address the artist's current and future stature in the art world. Thus, I clarify what the real concern is and address that. The other thing I do if they really want a commitment:

CLIENT: "Well, is this going to appreciate, or not?"

CONSULTANT: "You know, no one can predict the future, and anyone who tells you that s/he can, I would be suspicious of. However, history has a way of repeating itself, and all I can tell you is that this artist, thus far, has had a tremendous appreciation history. In 1980, an original by this particular artist went for five-hundred dollars, and now, that same-sized original would go for twenty-five-hundred dollars. Isn't that incredible? Now, I can't promise you that same thing will happen again in the future. On the other hand, I have no reason to believe that the trend will change dramatically."

The other thing I interject, by the way, is to educate them.

CONSULTANT: "You know something, Mr. Collector? You do not want to buy this piece of art work as a liquid investment. You don't because, I can assure you, you are not going to be able to set up shop and sell this piece five years from now for retail unless, of course, you plan to get into the art gallery business."

CLIENT: "Well, I didn't think so."

CONSULTANT: "Well, in that case, you want this for enjoyment, isn't that true? And you just want to make sure that you're getting good value. That I can assure you."

I stress the duration of enjoyment by saying, "This is something that will last you for the rest of your life. You can enjoy this for the next fifty years. What can you enjoy for fifty years for twenty-five-thousand dollars? Not your Mercedes. That's for sure. Your sofa, that you spent twenty-five-hundred dollars for, five years from now your wife's going to recover. Then, she's going to throw it out and get another one. This work of art will last... Forever. It is destined to become a family heirloom; you can give it to your children, and they'll give it to theirs. It will be enjoyed by you, by your children, and by your children's children. People love that.

And finally, when I talk about investment, for certain kinds of people, I stress that while this is not a liquid asset, I say:

"It is an asset. And what's really exciting, sir, as long as you're not planning to sell it on a retail basis down the road, this has lasting value and goes on the asset side of your balance sheet — just like your fine jewelry, antiques, and rare coins."

To support this line of reasoning further, I probe and find out what kind of collectibles they currently have. A lot of people collect rare coins, for example. A lot of people put their money into porcelain, ceramics, all kinds of things. And I say:

CONSULTANT: "Just like you have your nice, rare coin collection - you'd never want to part with it, would you?"

CLIENT: "No."

CONSULTANT: "It's something you get a lot of enjoyment from?"

CLIENT: "Yeah."

CONSULTANT: "But, at the same time, you get a lot of satisfaction from knowing that it has value. Well, on the asset side of your balance sheet, you can put the appreciated value of your art work. And you ought to keep your insurance man up to date on the appreciated value of your art work, just as you do for your antiques, your home and your rare coins."

And people appreciate that.

How Do You Justify The Art Work's Price Tag?

How you as an art gallery owner and/or consultant feel about this issue can make a significant impact on your clients.

CLIENT: "How do I know this is worth ten-thousand dollars? You guys are ripping people off here. It's just a picture. They just do some scribbles and boom, there it is."

CONSULTANT: "Yeah, this is America. You're a businessman. I'm just curious, you sell reverse osmosis modules. How do you price those?"

CLIENT: "Well, shoot, we have research costs we have to pay back. We have manufacturing costs, and there's a standard markup."

CONSULTANT: "Oh, how do you determine a standard markup?"

CLIENT: "Well, we take a look at what our competition is doing, etc."

CONSULTANT: "In other words, this is America, and bottom line -the market dictates the price, isn't that true? In other words, when Michael Jackson comes to town, you may have to pay five-hundred dollars for a front-row seat. Isn't that true? Now, no one artificially inflates that — if people want to pay it, they're going to pay it. It is worth it to them. And you know what? The exciting thing about this particular artist is that people want his work. It is in such demand that we can't keep it in the gallery. I mean, we're selling out. What are we going to do? Isn't that exciting? So, you ought to get this now because it might not be here tomorrow."

CLIENT: "I'd better make sure that I buy it at ten thousand, so I don't have to pay twenty next year."

CONSULTANT: "Fantastic. Congratulations. You know, you and I think alike on this. I am so excited. What a great opportunity."

Special Considerations For Former Buyers

For my former buyers or collectors, I may continue the discussion as follows:

CONSULTANT: "How do we get you going this year? How many pieces do you want to get this year?"

CLIENT: "Well, I'm not going to get any at twenty-thousand dollars."

CONSULTANT: "I'll tell you what, since you've acquired a few pieces before, what if I put together three or four pieces for you — put a package together? Maybe our figure is around forty thousand. (That's a perfect opportunity to do a package arrangement.) I'm going to offer this to you because you were smart, wise and had faith in our artists. How many years ago was it?"

CLIENT: "Five."

CONSULTANT: "Five years ago. I want to do this for you because I want you to continue to acquire his work. Can we work something like that out?"

CLIENT: "Great."

Strictly speaking, I'm going to discount the artwork. I'm willing to put together four or five pieces for a package (lower) price. Another scenario is to get them hooked on one particular piece, and maybe I'll give as a gift another smaller piece so that they feel like they're getting a "deal" or "discount"... or, better worded, a CONSIDERATION.

Many times my students insist, at this point, that their old clients will walk out if they don't get a bona fide "discount" versus a gift or package. The client may say:

CLIENT: "I've paid your price, and it's time that I got a deal."

CONSULTANT: "You know what, if there was some way I could do it and be fair, I sure would because I know you love the work. I tell you what — "

Then I offer them a package, so they feel like I'm doing my best to provide due consideration for their past patronage. I offer it even if I feel the likelihood of the multiple sale is low because you never know. The other thing is, if you don't have a gift to give, I would say that as part of putting together some sort of marketing strategy, you create smaller pieces that are specifically designed as gifts for former collectors. That

way you are doing something special for your bona fide collectors (as well as allowing an entry point for "new" clients who buy later in the artist's career).

Anticipate Your Packages

If you anticipate package or special offers, you will stay ahead of your past clients instead of reacting to their less-than-adequate reduced-price offers. Examples:

Calendars - Featuring some of your artists.

Books - Featuring your artists.

Generic books of interest to art collectors, like *Tax Benefits for Art Collectors, Dealers and Investors*, by Robert S. Persky.

Artist's Dedication - Contemporary artists can dedicate the back of the artwork. A special message indicative of the artist's feelings upon meeting the collector is always welcomed (along with signature and date).

Art Cases - The cases made to transport art (typically used by art consultants who carry framed pieces to remote locations) are great usable gifts that assist the true art collectors when rotating their art among locations (e.g., home to office or vacation home to primary home).

Show Specials

Why not once a year have reduced-price offers that can coincide with an already heavily financed event (show, exhibition, tour, fund-raiser, party)? By contacting your current clients ahead of the event you will give them the opportunity of acquiring certain pieces at unprecedented (and never to be repeated) savings. They will feel special, and many will succumb to their desires due to the extraordinary savings.

Predetermined Multiple Packages

Evaluate your margins, and strategically pair fast-moving pieces with slower moving pieces, large with small, known artists with lesser known, etc.

Hierarchy of Commitment

The following five-point hierarchy is something I keep in mind whenever I am closing out the interaction with a client.

1. CASH or CREDIT in FULL

2. LAYAWAY

3. HOLD: NON-REFUNDABLE

 REFUNDABLE

4. NAME and HOW to REACH (LOCAL & OUT of STATE) PERMISSION to CONTACT WHILE THEY ARE HERE

5. NAME and HOW to REACH (LOCAL & OUT of STATE) PERMISSION to CONTACT at HOME at LATER DATE

This sheet is to remind you of some "things to do" all the time. Always, always — no matter what they've told you — ask for cash or credit in full — even if you anticipate that there's only a slight chance that will occur. Always, always ask for cash or credit in full. I'm reminded of this myself. I was in the process several months ago I went ahead and got a nice car; I'd been going the humility route with my old Chevy for many years, and I had to get a nice car, and so, there I was with this old Chevy — trying to sell it. I didn't want to pay any insurance on it. One of the art consultants who worked for one of my clients was fairly new and didn't have a car at all. She expressed an interest. It was Barbara Arlington. Barbara came to me and said,

"Oh, you're selling the Chevy. Well, how much?"

I have to tell you the thing was worth about a thousand dollars or so. Used cars aren't worth a whole lot, but a thousand bucks I'd take!

I said, "But, Barbara, I want to get rid of it — six hundred and fifty dollars."

"What!" Now, she knew it was worth a thousand dollars. "What! Well, Zella, I'm just starting with the company, and I'm a brand-new art consultant. I don't make any money... yah, yah."

I'm not really trying to sell, so she's got me off-guard. I say, "OK, Barbara, I tell you what, I'll bring it in tomorrow. If you like it, I'll work it out. Don't worry about it. I'll work something out with you."

She says, "You know, I can't pay for it. You know that... impossible! I've got too many things going on right now."

"All right, can you give me a dollar? I just want to sign it over to you."

"Oh, OK, OK." Anyway, she wheeled around and said, "You know, I'm pretty sure I'd like to get it. If you make it six-hundred dollars, I'll pay cash."

I couldn't believe it. She said, "I wouldn't start a new job like this without money in the bank. I've got a whole different career here. I've got money in the bank."

So I have to be reminded of this myself. Always ask for cash or credit in full, automatically. Why, heck, my second-best selling course is for customers! I tell them what they should say. Why do you think they all come in and say it?" "No, thank you, I'm just looking." I'm just teasing.

So, after the clients say, "No, no, no, no, no," — two, three, four times — then you say:

> CONSULTANT: "Well, what if we can make the financial arrangements a little more comfortable? How much would you feel comfortable putting down on it today?" (Layaway)

Then there's really another level after Number Two, and that's the old Hold. Don't forget Number Four. If they're going to leave, and you can't get any kind of commitment from them that's formal on a particular piece, always, always ask for their name and how to reach them. And if it's a resort town, get where they're staying. I can't tell you how important it is to call them while they're in town. Find out how long they're going to be there, and also find out if they have "thought" about it. More frequently than you might imagine they say:

> CLIENT: "You know what? I'm so glad you called. I could hardly sleep last night thinking about it."

What do you say when you call them? Let me just say, you have to set the stage, properly, and then it's easy. You get to that point first in the closing room...

> CLIENT: "No, no, no, no, no, we have to have time to think about it."

> CONSULTANT: "You know, I appreciate that. I'm just curious. How long are you folks going to be here? Another week? Good. Well, if I can't encourage you to allow me to complete the paperwork on it, I'd like to go ahead and put your name on it and set it aside for you. I'm going to take it off the wall for you."

I do it more to help them think it through because often when I say that, before they go, I will have convinced them to go ahead and get it. Do you see? I'm working with them. I'm working on their behalf.

CONSULTANT: "I'm going to go ahead and put your name on it and set it aside for you."

CLIENT: "Oh, no, don't do it!"

CONSULTANT: "Hey, I want to do this for you. No problem. Now, which way are you leaning right now? How much time will you need? Do you think you'll make a decision before you go?"

CLIENT: "Well, well, well."

CONSULTANT: "Why don't I give you a buzz Thursday afternoon to see how you're feeling then? How does that sound?"

CLIENT: "Oh sure, no problem."

At that point, they feel very comfortable that you reduced the pressure from writing a check to allowing a phone call. They'll commit to just about anything at that point. That's the thing you've got to realize. So get them to agree to everything you need them to agree to.

CONSULTANT: "OK, fantastic, I'll give you a call."

And you call and you say:

CONSULTANT: "How are you folks doing this afternoon? Are you enjoying your vacation?"

CLIENT: "Oh, yeah, it's been great."

CONSULTANT: "I was just curious. Have you had a chance to think about that piece?"

CLIENT: "Oh, yeah."

And they always think about it.

CONSULTANT: "Well, would you like me to go ahead and do the paperwork on it then?"

Always ask a closing question. And on the phone it's particularly important to be short and sweet and to the point.

Often they'll say, "Yes, OK." But when they decide momentarily against it, I say, "Well, would it be possible for you folks to come back down because remember you mentioned..." — and it could be just about anything. Remember, anticipate; and I say, "I found something that you have got to have. Because, if you are ever going to seriously consider this piece, maybe in the future, down the road, you've got to have this." That's why when you have the deliberator types, you never give them everything because you know you're going to hit them again. Now a certain percent will come back in, and you can go at them again. A certain percentage will not come back in, but you're going to send things to them in the mail. You say, "Well, when do you think you will be ready?" And that's when you Recontact them yet again. You ask permission to Recontact them later, and that's Number Five. That's the last level of commitment.

Will The Call Irritate The Client?

To avoid irritating the client on the phone, your call has to be short and sweet; but by first asking permission, you've minimized that possibility. If they seem irritated, the thing you've got to realize is that, just like working with people in person, if you have caught them at a bad time, then that doesn't have anything to do with you. The first tiring that you always ask is:

> CONSULTANT: "Hello, Mrs. Jones, this is Zella Jackson with Gallery International. I was just curious, is this a good time to call? Have I caught you at a good time?"

That's one of the first things because, if they say,

> CLIENT: "Well, actually I just popped out of the shower, and I'm freezing right this second."

then you say,

> CONSULTANT: "Oh, fantastic, why don't I give you about fifteen minutes, and I will call back." Everything's fantastic, everything!

I'm telling you, that's the truth. Unless somebody just passed away, or something like that, it's fantastic?

That's how you have to feel. And, you see, if you do the right things and you're professional it is fantastic.

> CONSULTANT: "Fantastic. You know what, I'll give you a buzz in about fifteen minutes, OK?"

> CLIENT: "OK."

And you call them back in about fifteen minutes.

CONSULTANT: "Are you all done? Great. Well, listen, the reason I was calling you "

More often than not, that's what the irritation is that you pick up in their voice. You caught them at a bad time. So you call back at another time; that's all.

When you ask permission, you set the stage and similarly, for the last level of commitment, it might go like this:

CLIENT: "No, no, no, I won't pay cash/credit in full. I will not put it on layaway. I don't want to put it on hold. No, don't call me. I'm on vacation — don't bother me."

CONSULTANT: "Fantastic, I'll tell you what, why don't you go ahead and sign our guest book? You seem really interested in this particular artist. Would you like me to contact you if new pieces come out?"

CLIENT: "Yeah."

CONSULTANT: "Fantastic, right here. By the way, don't forget to include your phone number because we like to call everyone we send things to in the mail."

What about when you call the client, not on vacation, but at home later on, and you get the answering machine? What kind of message do you leave on the box? If I hit an answering machine, I make a decision depending on how far I got with the client in the past. I don't leave a message if I didn't get very far. If I've got pretty far into it with them, then I'll leave a message, but it's short and sweet, and it will be like this:

CONSULTANT: "This is Zella Jackson with Gallery International. I'm just calling because I sent something out to you, and I want to make sure that you received it. I'll try again later. Bye."

Then, if I hit the machine again, I don't leave another message. This is also true if it's a secretary or someone else that I don't want to talk to who is not the decision-maker. Then, I don't leave any more messages. Are you clear on why I do that?

Some of my students worry that the secretaries will recognize their voices. Even if s/he does, I'll say, "What was your name again? Shirley, I'll tell you, I'm really hard to reach. It would be so much better if I just go ahead and try back a little later, OK? Is

there a good time for me to call today or tomorrow?" They're not going to write a message if they don't have to.

The reason you do not want to leave multiple messages is simple: you don't want to irritate the client. When I get back to the office — my assistant is very efficient and she gives me my stack of messages. The first thing I do when I see four or five messages from a salesperson is I ask, after about the third one, "What is he calling me for?" When I just get one, and it's a week old, I look at it and say, "Oh, what is this?" I'm trying to figure it out. I'll call back. You know what my whole tone of voice is? "You know, I'm really sorry I didn't get back to you, but I was on a trip, dah, dah, dah "I have a whole different attitude. I didn't get the feeling that the salesperson was trying to "bug" me.

But what if you don't get any call back by Friday from your first message, and you left the message on Monday? You call back. You call back. In other words, you keep calling until you hit the decision-maker.

Well-to-do people, particularly business people, even well-to-do people who are not in business and who have inherited their wealth, are busy with their social commitments. Don't give the impression that you are desperate and that you are bugging them. Instead, give them the impression that you are just as busy as they are. The story about not being reachable should be true, or fake it till you make it. If you've got a lot of time on your hands, you don't want to let people know that.

How Do You Get Usable Names, Addresses and Phone Numbers?

This is how you do it. People will leave the clients to their own devices with the guestbook. Don't do it. Walk them through it. This is what I do with them. I have the guestbook there and say:

CONSULTANT: "Before you go (and this is after "no, no, no, no")... you, at the very least, have to sign our guestbook, OK?"

CLIENT: "Oh, sure, no problem."

And I go and walk them over there and say:

CONSULTANT: "OK, now use the name that you usually prefer. Do you have a business by any chance? Or would you prefer us to contact you at home?" You're facilitating their decision.

CLIENT: "Oh, it's much better if I give you my business card."

CONSULTANT: "Why don't you just do that."

Then, boom, you don't have to go any further. They say, "Oh, well, why don't you send it to me at home. Otherwise it could get lost. I work for a big company..."

> CONSULTANT: "Fantastic. All right, would you make sure you put your phone number down?"

They'll look at me funny sometimes when I ask them. "I'm going to call you to make sure you received what we sent. We send out some beautiful brochures. I want to make sure you receive it and see what you think about it. We have to stay in touch with our market. I want to see how you feel about it — whether you like a particular piece or not — because maybe I will need to send you something else, OK?"

> CLIENT: "Oh, OK."

Another factor is people have handwriting you can't read!!! How do you overcome that?

Immediately after the client signs the guestbook, I have a pen in my hand, and I say, "You know, l want to make sure I can read this. You have your first initial here as "J." What is your first name, sir?" And then he'll tell me, and I say, "Do I have the spelling correct? I'll print it right underneath. Let me see if I can read your last name — and the zip." And I go right over it, and I say, "It's no good unless we can read it, isn't that true?"

> CLIENT: "Yeah, you're right."

> CONSULTANT: "No problem."

You've got to treat this like it's worth money to you because it is. Heaven forbid, if Gary Smith ever got run over by a truck, and he happened to have his client follow-up book under his arm! I mean, it would be real sad, of course, if he passed away — but if you were thinking clearly, you would run in the street and save his book! Let me tell you, that book is worth money!

Words to Avoid and Those That Are Better is a list you will wish to study.

Words To Avoid And Those That Are Better

AVOID	TRY
Print	Graphic
Picture	Image, Painting
Purchase	Own
Buy	Acquire
Deal	Agreement, Offer
Price	Value, Investment Level
Pay	Take Care Of
Discount	Offer, Opportunity, Arrangements, Option
Closing Room	Better Place, Dimmer Room

If you want to upgrade and become a little more professional about presenting the world of fine art to people, instead of saying "print," use the term "graphic." It sounds more sophisticated. Now, I still find myself saying the word "print" a lot because it is used so frequently, but whenever I'm talking to someone who seems to be very knowledgeable in the art world, usually people from back East, for example, then I click right in, and I want to use the word "graphic." For general mailouts, particularly with the low-end, multiple works, you're going to find the word "print" is probably OK. In place of the word "picture," I prefer the term "image." Instead of "purchase" — "own." Instead of "buy" — "acquire." Instead of "deal" say, "Do we have an agreement?" "Do you want to offer?" Instead of "price" — and this one's another hard one — particularly in writing, "investment level" sounds a little pretentious and cumbersome, but verbally, it works really well.

"The investment level for this piece is..."

A lot of people I've talked to at galleries call money "funds"... "the funds required." Instead of, "How do you want to pay for this?" it's, "How do you want to take care of this?"

Instead of "discounts — we never offer discounts — "We have an opportunity for you." "Options" and "arrangements" are equally useful instead of "discounts."

Instead of a "closing room" we call it a "dimmer rooms" or best of all, a "better place." "Let's take it to a better place, a more private place."

Direct Mailings And Follow-Up

All direct mail contacts with clients should be followed up with a phone call. The only exception is the straight thank-you note immediately after a client acquires art work. Everything else that is sent out must be followed up by phone to maximize the return. Otherwise you can anticipate the standard from so-called mass mailings of one-half of one percent (.5%) to one and a half percent (1.5%) return.

Obviously, unless you have a huge mailing list, these statistics will not serve you well. On the other hand, if you wish to build a strong client base, always call after a mailout. By doing so you can anticipate a return of seven to twenty percent and even substantially higher. Other variables that affect results include: art consultant's telemarketing competence, artwork appeal, etc. The good news is that these variables can be positively influenced by training consultants, offering incentives, and carefully selecting the pieces. Further, once their homework is done, many of my clients with the direct mailing and a phone follow-up will sell out an entire edition of four hundred within a year of release with a third or more sold as a pre-publication offer.

How Do Galleries Work With Consultants On Corporate Mailings?

Again, galleries differ. Many galleries that are on the larger side will do a corporate mailout, and then they'll have a sales meeting. They'll say, "These are going out. They'll hit the streets next Thursday. You have this window of opportunity to call over a period of four days. You call your top twenty percent clients. If this equates to a hundred or less, you call them all." If you adopt that strategy, then you're going to have phenomenal success with your direct mail campaign.

Personal Letters For Special Collectors

Once you have a track record with collectors over many months or years, you can invest much time and money on each one. This strategy will only augment your other selling until income from serious collectors outpaces gallery traffic and other repeat buyers.

My clients send out by Federal Express expensive hardbound portfolios with full-color 8 1/2" x 11" photographs. While the return on this basis can be extremely high (seasoned art consultants report fifty to one hundred percent return), quite often the time it takes for such big decisions to be made can span sixty to ninety days (or several pay periods). Thus, I strongly encourage a balanced marketing strategy for most art consultants.

Personal Letters For Corporate Mailings

I prefer letters in envelopes over cards. They are individually addressed to each person. Just as with any kind of selling, the closer you can get to the intimate, the greater the likelihood of success. A computerized mailing with labels is getting away from this concept. If it's just a postcard with a label, you get further away; and you get closer if it's personally addressed to an individual and, if it's handwritten, you're very personal.

If there's a label on the envelope, then it's junk mail. If it's hand-addressed, it's personal.

Letters should be hand-signed. But again, that's sometimes impossible if you're talking about a mailing of several thousand pieces. I recently talked to one gentleman who had a mailing list of twenty thousand. I'd be crazy to suggest that he hand-sign every one. You can use a facsimile signature in a second color. If you've got a reasonably short list, one that would take only two to three hours, you should hand sign those. It's simply more powerful. If you want to make it even more powerful, consider the following: You do a hand-signed mass mailing, and let's say you as an individual art consultant have five hundred clients. At the sales meeting the notification was made, etc., and your sales manager says, "All right, I want each art consultant to call a minimum of one hundred people." What you want to do is pull out your one hundred best qualified clients. Take your top one hundred and write a little personal note across every single one of those corporate mailout letters that says, "I will be calling you by the end of next week because I know this will complement your current collection. I feel confident that this will be an excellent addition to your collection." Then you call those and allow the other four hundred to experience "institutionalized advertising." As corporate mailings come up in the future, you cycle a portion of the four hundred into your phone follow-up so as to allow direct phone contact with all five hundred people over a period of time (six months to one year).

This strategy dictates organization. You must have an organizer because there is no way you can remember what you've said to a hundred people. It must be strategic and automatic. You have to have records.

What Makes An Effective Corporate Mailing?

1. Obtain and hold interest fast.

2. Reassure and compliment the client on his/her artistic taste.

3. "Romance" the artist and the image.

4. Always "seek action." Encourage them to call now.

5. Keep the letter short — one to two pages maximum.

6. State the price in all large mailings.

7. Provide an accompanying brochure or sheet with photo, dimensions, title, brief "romance" (legend, symbolism, etc.), and price. The brochure (or sheet, with photo) should be redundant to some extent. Be sure to allow key information (e.g., dimensions, edition size, price) to really stand out, as this allows for better retention.

ANALYZE SUCCESS AND REPEAT IT!

Examples of Direct Mail Materials

Review the following direct mail materials. Most are disguised versions of actual campaigns that were successful. While you may object to style, don't argue with success.

April 12, 19___

Dear Friends:

Kinzo Okada continues a tradition of excellence, rich creativity, and superior quality with his latest limited edition print entitled "THE FATHER AND SON." This is sure to follow in the footsteps of earlier limited edition prints. (Others have quickly sold out and tripled in value within two years.)

Okada's "THE FATHER AND SON" is a celebration of the son's emergence into manhood. It reflects strength, perseverance and beauty, as father and son dance in the shadow of the majestic pine tree, the Japanese symbol of strength and endurance. Consider the following:

1. Only FIFTY PRINTS are offered at the prepublication price of $1400, un-unframed, on a first come, first served basis.

2. A $700 deposit is all that is required to reserve your state-of-the-art mixed-media print. The balance will be due upon completion, expected to be in late May, 198___.

3. Upon publication, this same print will cost $1800.

4. And, as always, we guarantee your satisfaction or a complete refund.

If you love Okada's work and enjoy the symbolism, beauty, and grace of "THE FATHER AND SON," then there will be no better time than right now to acquire his work. Call me today at (800) ___ - ____ to reserve your print.

With warm regards,

Your Name
Art Consultant

YOUR GALLERY
825 Main Street • Anytown, USA 96813 • (800) 538-3907

Dear Drake Collector:

Aloha from your paradise home! Two new Drake suites, plus a graphic that is so excitingly different that it "runs circles around anything else," are being introduced. The "MOTHER AND CHILD SUITE," the "RICH WITH HISTORY SUITE," and the graphic "ALWAYS SUMMER" represent a quantum leap in creativity for Roger Drake.

The "MOTHER AND CHILD SUITE" honors the bonding of the largest mammals ever to have lived on earth. Now battling extinction, Drake immortalizes these magnificent creatures in two pieces that celebtrate their fight for life.

> "MOLOKINI'S FIRST BREATH" shows the newly born calf just at the water's surface, breathing air for the first time. The crystal clear blue waters just off Maui's coast are bountiful with tropical fish and colorful coral, and it is here that the humpbacks have calved for centuries. The crescent-shaped Molokini is the rim of an ancient sunken volcano and acts as the backdrop for this birth drama, as it has since time immemorial.

> In contrast, "STEINBECK'S CANNERY ROW" depicts a gray whale and her calf in the rich kelp beds off the Monterey, California coast. In the background, civilization spills down from the hillside to complete the ironic ballet; the world's most intelligent creatures "dance" in delicate balance with the world's largest. The "MOTHER AND CHILD SUITE" takes us on the journey that begins with new love, new life, and new hope.

The "RICH WITH HISTORY SUITE" captures one of life's truisms as expressed by Winston Churchill: "The farther backward you can look, the farther forward you are likely to see." Drake has looked back in time and brought new meaning to our present.

> "ATHENIAN ODYSSEY" takes us back to the ancient ruins of Greece and Rome. Acropolis, the majestic Greek fortress, sits atop an imaginary Grecian island in the fifth century B.C. while "Atlantis" hovers below in poetic mystery. And finally, dolphins play amongst the ruins as if they knew that Greek artists were the first to immortalize them as "friendly spirits of the sea."

YOUR GALLERY
825 Main Street • Anytown, USA 96813 • (800) 538-3907

"KILAUEA LIGHTHOUSE" takes us back to the turn of the century when this majestic beacon directed ships as they passed Hawaii to and from the Orient. The rugged cliffs of Kauai's north shore plunge to the tropical undersea world below. Here, again, dolphins play with total abandon just as the old Hawaiians had characterized them . . . "sea creatures with sunny hearts." The "RICH WITH HISTORY SUITE" is two worlds, two cultures, two histories – and yet they are one in a single, timeless moment.

And finally, we offer a spectacular graphic that is so unique you will not be able to resist its "well rounded" charm. "ALWAYS SUMMER" is a circular piece that gives the feeling of looking into an open ocean fishbowl. And to add to Drake's undersea fantasy, the frame comes with a custom designed acrylic bubble!

A sunbeam bursts from its center while colorful reef fish and dolphins cavort among the diverse coral formations that surround the Hawaiian islands. This exciting, new perspective is sure to delight and astound you.

To acquire your Drake pieces, call your fine art consultant toll-free today or simply fill out and mail the enclosed order form. If you wish, you may obtain any graphic individually. The choice is yours and will no doubt enrich your world now and through the years. But remember to order now because our pre-publication prices are the lowest at which these pieces will ever be offered. Call us toll-free today!

With warm aloha,

James Wells
General Manager

P.S. Those acquiring either suite before February 1, 19___, will receive two free gifts (a $_____ value): (1) the book, *The Art of Roger Drake;* and (2) "The 19___ Roger Drake Calendar."

Also, remember to RETURN THE JENSON POSTCARD – TODAY!

January 5, 19___

Dear _____,

As a Jon Underwood collector, you are in great company. Among his collectors are such well-known persons as President Reagan, Robert Wagner, and John Denver. They, like yourself, appreciate the beauty and majesty of an Underwood piece.

As a dedicated Underwood collector, you are sure to appreciate this invitation to acquire "HARMONY," his most prestigious limited edition graphic yet offered. This two-world piece is a "Tahitian Fantasy" that truly reflects Underwood's romantic vision of the Pacific Islands. Lush hillsides, sleepy sailboats, diving dolphins, and playful sea turtles say "freedom," all in harmony with Underwood's tropical world.

Aside from its aesthetic qualities, "HARMONY" is an even greater treasure because it has been selected to hang in the permanent collection of the Metropolitan Museum of Modern Art in New York City.

And now, I invite you to celebrate this great honor with Underwood. As Sr. Art Consultant, I am offering you this piece at substantial savings over the new gallery price of $850. If you place your order by March 31st, you may acquire it for only $700. Think of it! This is a savings of $150.

To reserve yours, simply place a deposit of $125. Only fifty have been set aside exclusively for my Underwood collectors. Send your check today to Your Gallery, or call (800) 538-3907 to place your credit card deposit. Because this is a special offer, please ask to speak to me directly.

I trust you share my excitement about this excellent opportunity. "HARMONY" will be both a personal treasure and a reflection cf your tribute to a great artist.

With warm regards,

Eva Johanas
Sr. Art Consultant

YOUR GALLERY
825 Main Street • Anytown, USA 96813 • (800) 538-3907

February 10, 19__

Dear Friends,

As a Rick Gordon collector, you are in great company. Among his collectors are such well-known persons as Gregory Peck, Erma Bombeck, Elizabeth Taylor, and Jackie Onassis. They, like yourself, appreciate the beauty and serenity of a Gordon piece.

As a dedicated Gordon collector, you will surely appreciate this invitation to acquire "WEDDING BASKET," his finest tribute to the Navajo Woman yet created. This fine limited edition graphic reflects Gordon's romantic vision of a young Navajo woman being readied for her marriage ceremony. The wiser and older woman has just cleaned the bride's hair with the juice of the yucca plant and brushes her lush black hair into the traditional bun, "Chango." We imagine a quiet yet profound exchange of wise, fundamental truths as the soft southwestern desert colors envelop the "WEDDING BASKET."

"WEDDING BASKET" is a tribute not only to the Navajo woman. It also universally celebrates the emergence of conscious womanhood. And now, I invite you to bring this piece and its message into your life. I am offering this fine graphic at substantial savings over our new gallery price of $2500. If you place your order by March 31, 19__, you may acquire it for only $2000. Think of it! This is a savings of $500!

To reserve yours, simply place a deposit of $500. Only twenty-five have been set aside exclusively for my Gordon collectors. Send your check today, or call (800) 667-9112.

I trust you share my excitement about this outstanding opportunity. "WEDDING BASKET" will be both a personal treasure and a reflection of your tribute to a great artist.

With warm regards,

Lori Kanemaru
Art Consultant

YOUR GALLERY
825 Main Street • Anytown, USA 96813 • (800) 538-3907

"Who is one of the most exuberant actresses you know of?"
Lucille Ball !!!

"Who collects Jean Marson?"
LUCILLE BALL !!!

July 9, 19___

Dear Marson Collector,

Greetings from your coastal village home! Two new Marson suites are being introduced that are simply superb. The "GLORIOUS LAZY AFTERNOONS SUITE" and the "FLORAL FANTASY SUITE" pay tribute to the beauty all around us and act as exquisite reminders that we should enjoy it NOW!

The "GLORIOUS LAZY AFTERNOONS SUITE" honors the lost art of relaxation. Five original oils on canvas entitled, "Shady Spot—Provence," "Arbor in Summer," "Lunch on the Porch," "Summer Lunch along the Potomac," and "Sunny Patio" all beseech you to "enter in," take a chair, enjoy the scenery, and experience the beauty all around you. So often we are pushed through our lives. Acquire one or all of these Marson pieces and rejoice in loving life

The "FLORAL FANTASY SUITE" is a triumph of exuberant colors with joyful flowers seeming to spill from the canvas. Four pieces, "Spring," "Garden Walk," "Bouquet in the Window," and "Mt. Vernon Garden," all make you "stop and smell the roses" if only for a moment. What a delightful way to brighten any room or office.

Again, you may acquire any pieces separately, in pairs or as part of the entire suite. The choice is yours. The Afternoon Suite is $ _____ and the Floral Suite is $ _____. Suite prices represent a 30% SAVINGS over individual acquisitions. And until August 10, 19___, individual pieces are available at substantial savings. I will call you by the end of the month to see how you feel about these suites, or call (800) 610-5003 for prompt service.

Warmest regards,

Your Art Consultant

YOUR GALLERY
825 Main Street • Anytown, USA 96813 • (800) 538-3907

May 25, 19__

Dear Valued Client,

An unprecedented "marriage" is taking place in our exclusive world of fine art: Carolynn Lee and Hitoshi Okuda, artistically together. The soft sensuality of Carolynn's "MOON-SONG" has been joined with Hitoshi's innovative "EYES COLLECTION" to form our "WEDDING FANTASY SUITE."

After serving as a Sr. Consultant at Your Gallery for many years, it takes special pieces to truly ignite my imagination. The "WEDDING FANTASY SUITE" is just such a collection of art work. I have put it together for only a small select number of my clients . . . those I have felt would especially love the artistic union of Lee and Okuda.

The gentle curves and soft hues of Carolynn Lee's work unite with Hitoshi Okuda's sweeping lines and bursts of color in this spectacular collection. Only ten suites have been set aside for $2000 until June 30, 19__. Think of it . . . four exquisite prints for what most fine art collectors expect to pay for just one. Bring these artists into your hearts as a perfect union of artistic imagery. For many, due to its value and loveliness, the "WEDDING FANTASY SUITE" is a dream come true.

I will call you by the middle of the month to see how you feel about this collection.

Warm regards,

Your Name
Sr. Art Consultant

TIME: Offer good until June 30, 19__
PLACE: Your Home or Office
PHONE: (800) 926-5003 or (800) 538-3907

YOUR GALLERY
825 Main Street • Anytown, USA 96813 • (800) 538-3907

June 5, 19__

Dear Friends,

It's SHOWTIME, again! After our recent resounding success at the New York Art Exposition (the largest in the world), I am pleased to invite you to our follow-up show, the Better Homes Show, Neal Blasdell Exposition Hall, June 17–21.

We are re-creating the N.Y. Art Expo for YOU! We will be unveiling exciting new works as we did in New York. In addition, we are featuring our newest world-class artist, never before seen in Hawaii!

As always, we will offer special prices during the show. And lastly, it will be fun to get together again. Come and visit all your old friends at Your Gallery. We would love to see you, and don't forget to bring your family and friends.

I'll be calling you by the end of next week to let you know when I will be there so we can be sure to get together. See you soon!

Aloha,

Alaine Porter
Art Consultant

"Arguably the most famous and popular living visual artist
in the world — Steven Coe."

ART IN USA, 3/84

July 17, 19__

Dear Valued Client,

Once an artist reaches world-class status it is often far too late for the collector to dream of
acquiring "A FIRST." And yet, such an opportunity for Coe collectors has arrived!

I am proud to offer Coe's first sculpture ever published in the *Steven Coe Sculpture
Collection.* This exquisite bronze sculpture entitled "BOLD" is a tribute to the noble horse,
a creature for whom man has always felt a certain reverence.

In Coe's own words, "The horse has carried the adventurous, the brave, and the inquisitive
to new lands, and has borne warriors into battle." So many of us can align ourselves with
this symbolism as we face the day-to-day challenges of our lives. Invariably we face our
challenges with strength that may well be considered "bold" as we pioneer new solutions to
old problems.

I am proud to offer this "first" to my Coe admirers. I am confident it will become a collec-
tor's item of premier importance. The prepublication price of $3600 is available until
September 1, 19__. While the publication price is set at $ _____, I fully expect each
piece to be reserved prior to publication.

If you love Coe's work and enjoy the symbolism, beauty and grace of "BOLD," then there
will be no better time than right now to acquire "A First." I will call you by the end of the
month to see how you feel about this piece.

Warmest regards,

Your Name
Art Consultant

Making That Call

The most important thing to remember about calling your clients is: MAKE the call. So many art consultants simply do not structure their time to allow high-quality phone interactions with clients.

A checklist follows that helps you get prepared for your telemarketing campaign. Schedule two to four hour sessions, pull out your client records, and dial. Whenever you make that call, remember your objectives:

1. Sell Now.
2. Set the stage for future business.
3. Obtain referrals.
4. Obtain permission for next contact.

Follow-Up By Phone

Phone Techniques — A Checklist

1. Preselect clients to call from your Organization System.

2. Determine the best time to call for each client (for most people, call between 7 and 9 pm their time).

3. Always introduce yourself immediately. Then ask if this would be a convenient time to talk. If yes, continue; if no, ask if you can call at a more convenient time (don't forget to find out when).

4. Ask whether or not they have received the letter and "flyer" (or newsletters, invitation, etc.).

5. Qualify them:

 "How do you like it?"

 "How do you feel about it?"

 "It's beautiful, isn't it?"

 "Do you think this might fit nicely into your current collection?"

 "Do you think this might be the piece to start your collection?"

6. Describe the piece in your own terms (remember FACT- ADVANTAGE-BENEFIT). ELABORATE on those features that might be most appealing

to them (e.g., high-quality prints, colors, symbolism/ legend, size, best time to buy, etc.). Ask for their AGREEMENT ON ALL KEY POINTS.

7. Reassure them of the features that are IMPORTANT TO THEM.

8. Ask a closing question:

"Shall I take your deposit now?"

"Can I take your credit card number on the phone, or would you like to write me a check?"

"What would you feel most comfortable sending me for your deposit?"

"So, would you like me to go ahead with the paperwork on this? All I need is a fifty percent deposit. Does that feel comfortable for you?"

REASSURE THEM OF THEIR DECISION TO ACQUIRE THE PIECE!

DO THE EASY ONES FIRST...

...Remember, you have a hundred calls to make. It might go something like this:

Ring, Ring...

CLIENT: "Hello."

CONSULTANT: "Hello, Lisa?"

CLIENT: "Yes, it is."

CONSULTANT: "Fantastic. This is Zella Jackson with Gallery International. How are you today?"
CLIENT: "I'm fine."

CONSULTANT: "Is this a good time to talk?"

CLIENT: "Uh, sure."

CONSULTANT: "Good. The reason I am calling you is I want to find out if you've received my letter did you get that?"

CLIENT: "Yeah, I did."

CONSULTANT: "Great. What did you think of it? Beautiful piece, isn't it?"
CLIENT: "It was very nice."

CONSULTANT: "You know what? When it first came out, I thought of you. I said, 'Lisa would love this.' And, I told myself,

'Boy, I've got to call her right away, because this is not going to last.' Lisa, do you like it?"

CLIENT: "Yes, I do."

CONSULTANT: "But you don't just like it — you love it, don't you?"

CLIENT: "Yes, I love it."

CONSULTANT: "Why don't we go ahead and ship it out to you, OK?"

CLIENT: "Yes."

CONSULTANT: "Now, how would you like to take care of that, Lisa?"

CLIENT: "Uh, let's put it on my American Express."

CONSULTANT: "Absolutely. I am so glad that I called you. I tell you what, we have something else that's coming up, and..."

I wanted to illustrate an easy one because when they buy, they buy. She just spent. She knows how much it costs. We haven't even talked about that. Payment in full is what I asked for first. Before I let her go, it was so easy I'm going to ask her to buy something else.

CONSULTANT: "Lisa, before I let you off the horn here — I know you're a busy lady. I'm just curious. There is another piece that we haven't even made available to the public yet, and, I tell you, it is — I think it is just gorgeous — The Black Swan. In fact, I'd like to go ahead and set a piece aside for you based on your approval, and I'll send you a photo. We don't even have a brochure on it yet. Why don't I go ahead and do that too, OK?"

CLIENT: "OK."

CONSULTANT: "Lisa, you know, you've been wonderful, and, I tell you, we're going to be in touch, and I'll let you know when the piece is available to ship out to you, OK?"

CLIENT: "Thanks a lot."

CONSULTANT: "Bye."

CLIENT: "Bye."

For many of the calls, it will be that straightforward. A lot of my clients who have little telemarketing experience don't believe me on this at first. Once we do one, they have an incredible "Aha" experience that reinforces everything. Just recently I had a client do a direct mail with a price special that expired on a certain date. Well, we had our sales meeting and encouraged the art consultants to call and take advantage of the four-day window of opportunity. On the day before the special expired, a lady called in and said, "Gee, I was waiting for someone to call, but I'm afraid the special will expire, so please take my gold card number."

WHAT IF THEY DISLIKE THE IMAGE?

In the very beginning, if they say, "That's the ugliest thing I've ever seen," what do you do?

You have to redirect. You cannot sell someone something that s/he doesn't like. Remember that don't put yourself through the agony.

Redirect, and you go to Number Four in the Hierarchy of Commitment:

"Would it be all right if we stay in touch, and I'll keep you up to date? Fantastic. Let me just verify your business address (or whatever)." Because I'm organized, I flip through to their purchase history. "How are you enjoying your...? Great." And then I go for the referral. You know, I'm going to make the most that I can of this phone call: "Well, while I've got you on the horn, have any of your friends spoken highly about the piece that you have hanging in your living room? Great. By the way, it was shipped out on time, wasn't it? You received it when you needed it for that dinner party, right? Great. Do you think there are other people who really admire the piece, some of your friends, perhaps, who might be potentially interested in what we do down here? Fantastic. If you give me the name of your physician and your dentist and your lawyer and your business partner, I will commit to following up with those people. I'm going to send them — in fact, I'd like to send them The Black Swan because, even though it wasn't right for you, I'd like to introduce them to Jon Underwood, OK?"

TELEPHONE SCENARIO WITH VALUE OBJECTION

OK, now, the final concern is they are shocked at the price. Actually, we will discover, it is an issue of VALUE.

CLIENT: "I will not pay that for the piece."

CONSULTANT: "You know, I appreciate that. I'm just curious, what kind of art work do you have?"

CLIENT: "What kind of art work do I have? Watercolors, mainly."

CONSULTANT: "Watercolors, mainly — and you just never found one that was in that range is that what it is?"

CLIENT: "I just feel uncomfortable about spending eighteen-hundred dollars for a watercolor."

CONSULTANT: "I see, and is there any particular reason why? Can you pinpoint that for me?"

CLIENT: "Most of all the watercolors I've purchased over the years have been around the five to eight hundred dollar price."

CONSULTANT: "I see. So your main concern is that this is something you've never done before. Is that correct?"

CLIENT: "I've never done it."

CONSULTANT: "OK, you know, I can appreciate that. The first time you do something it's always a little scary. You're talking about four times what you've ever experienced before. That is kind of scary, but I've learned a lot about watercolors and their value. Can I share a little bit about that with you?"

CLIENT: "Please."

CONSULTANT: "OK, first of all, this particular artist you don't have in your collection at this time, is that correct?"

CLIENT: "No, I don't."

CONSULTANT: "Now, when you buy — when you acquire an image— a painting — you're acquiring something by a particular artist. This is one thing you want to consider, and this particular artist is world-renowned. I might add that in Europe, watercolors are highly coveted. Isn't that fascinating? Do you know why? It's because with oils, you can dab it up, and cover up any old mistake, but with watercolors, guess what? Once it's committed, it's committed. It's kind of interesting that we Americans love

hamburgers and ketchup. The Europeans, who, of course, have taken the world pretty far forward in the realm of fine art, believe that watercolors are even more valuable. Isn't that interesting?"

CLIENT: "Very interesting."

CONSULTANT: "So, when you stop and think about it, we have the combination of the prestige and world renown of this artist, plus the fact that this is the finest watercolor I've ever seen. Isn't that true for you too?"

CLIENT: "It's beautiful."

CONSULTANT: "There's no reason not to go ahead and make this investment. Can I send it out on approval?"

CLIENT: "Send it out on approval."

While you might have to spend a lengthy amount of time to reorient the client, you are just handling concerns. What s/he's saying is, "Help me to justify this acquisition." And I did.

ART CONSULTANTS COMPLAIN?

If they're doing it properly, then they're going to be successful at it, and the smart ones are not going to complain. They're just going to do it. That's my experience with it. Some of my art galleries schedule consultants four days on the floor and one day just to follow up by phone. It means so much money as well as perceived high-quality service.

KEY POINTS

Always introduce yourself immediately, which we have already illustrated. "May I ask if it's convenient?" If it is "yes," continue; if "no," set up another phone appointment. Ask if they received what was sent. Qualify their motivation. Presumably you already know if they can afford it. Describe the piece in your own terms. Get them to agree on all key points. Reassure them of the features that are important to them. Always, always ask the closing question. Otherwise, there's no point to the phone call — you're wasting your money. Don't even bother if you're not going to ask them to buy it. Save yourself the trauma. No guts, no glory! Reassure them of their decision to acquire the piece. If, on the other hand, they say that this is the ugliest thing they've ever seen, at the very least, ask for a referral.

CALLING THE PROSPECT

Ring, Ring...

CLIENT:	"Hello."
CONSULTANT:	"Hello, this is Zella Jackson of Gallery International. How are you today? Great. Have you got a few minutes? Great. I really appreciate your time. Mr. Jones encouraged me to call you."

That's my favorite phrase. It really perks them up. It's not a lie; you asked, and the client encouraged you. And then, if you've got your notes, you don't even have to think. You've got a little note, and it says the context of the entree: "Mr. Jones had you to a dinner party, and you mentioned that you thoroughly enjoyed the piece." — and you go from there.

Review the following guidelines for calling the prospect.

FOLLOW-UP WITH PROSPECTS BY PHONE

The following guidelines are provided for your consideration as you approach a client via the telephone. Review them for their concepts rather than as verbatim speeches. A sales technique is effective only if each salesperson incorporates his/her own thoughts and style.

PROSPECTS

1. "Hello, Mr._____, this is _____ from _____ Mr. _____ encouraged me to contact you regarding our Gordon limited edition prints (or show, promotion, etc.). Do you have a few minutes to talk with me now?"

2. "Great! I really appreciate your time, Mr._____ Well, has Mr._____told you much about Rick Gordon? Have you had a chance to view his work?"

3. "Gordon is an internationally known artist with a free-flowing style. His work is both dramatic and symbolically compelling at the same time. Gordon has been instrumental in America's rediscovery of itself. His Navajo-woman creations are created with fresh, vivid colors. Gordon is considered by many as the 'Picasso of American Indians.'"

4. "Tell me... what art work do you currently have?"

5a. "It sounds to me like you like _____ style, scenes, etc., don't you? Well, I believe Gordon's work would be a complement to your current collection. Would it be possible for us to set up an appointment? Here in the gallery would be ideal so that you can see the widest selection currently available. Would Thursday at _____ or Saturday at _____be convenient?" (For a few select prequalified prospects, you may wish to arrange a private showing in their homes.)

5b. "I am happy to say that I personally have introduced more than _____ hundreds of first-time investors to Gordon's work, and all of them report great enjoyment. Further, they each enjoy the high-appreciation-value trend that his work has experienced. All of his limited edition prints have doubled in value within ___ months. Wouldn't you like to have more information regarding Gordon's work before you make a final decision? Can we set up an appointment this week? Would Saturday at _____ be convenient?"

6. "Thank you very much for your time. I look forward to our meeting. Perhaps I'll call you on _____ afternoon to reconfirm our meeting."

Show Protocol And Pre-Show Follow-Up

Review the following two forms. The Show Protocol form gives succinct guidelines on how the Gallery Director can guide the art consultants to a successful show (or other event).

Remember, a show invitation is directly mailed and must be followed up with a phone call to maximize your return. Also, pre-sell as much as possible prior to the event. For example, a show will be far more successful if art consultants have got several "maybes" on a few high-end pieces and many "yeses" on medium to low-end pieces. These pieces would all be displayed prominently with discreet color-coded stickers to indicate status. This (along with everything else) will stimulate people to make their final decisions to acquire the art.

The second sheet sets out Pre-Show Phone Techniques to aid with the follow-up.

□ □ □

SHOW PROTOCOL

(1) In order to ATTEND the show each Consultant MUST:

 (a) Sign up a minimum of 10 clients who will possibly attend the show.

 (b) Hand out or mail out invitations and personalize with special information or values.

 GOAL: 20-40 Names, Local Phone Numbers and Contact Information

 ACTUAL: 10 Minimum in order to attend the show

(2) A Special Guest Show Book will be available. Permanent/Local follow-up information and Title(s) of piece(s) interested in should be obtained.

(3) Telephone follow-up MUST be made by EACH consultant from 8 to 48 hours before the show to indicate client attendance. Log sheets provided by the gallery must be turned in to the General Manager by NOON the day of the show. Consultants who do not comply MAY NOT ATTEND the show.

PRE-SHOW PHONE TECHNIQUES

1. Call EVERYONE you have invited to the show to confirm attendance.

2. Determine the best time to call for each client (for most people, call between 7 & 9 pm or 8 & 9 am).

3. Always introduce yourself immediately. Then ask if this would be a convenient time to talk. If yes, continue; if no, ask if you can call at a more convenient time. (Don't forget to find out WHEN!)

4. Tell them you are calling to confirm their attendance at the show. Reinforce how fun and exciting it will be.

5. Be DIRECT and yet REASSURING:

 "I look forward to seeing you there, then!"

 "Can't wait to show you the piece that will be unveiled it's breathtaking!"

 "Can I count on you two? I'm letting my General Manager know how many of my V.I.P. clients are attending so we can have enough champagne!"

 — You May Wish To Close Here —

6. If you continue, Firm Up a Sale! Describe the art work in your own terms (remember FACT-ADVANTAGE-BENEFIT). Elaborate on those features that might be most appealing to that person (e.g., highly polished, limited editions, high quality, color, symbolism/legend, size, best time to buy, etc.).

7. Reassure them of the features that are important to them.

8. Ask those closing questions! See the sample questions in Follow-Up Techniques

SECTION THREE — BUILD PASSION WITH ROMANCE

Introduction

The more time you spend, the more results you will achieve. Studies have shown that in clocked interactions with clients on big-ticket discretionary items, such as fine art, the more time you spend with the person, the more likely you're going to get some bottom-line results, i.e., sales.

Why?

The more time you spend with someone, the more opportunity there is to establish a profitable rapport. People buy things when they trust you.

How many of you have ever read The One-Minute Manager? Have you ever seen the video tape? In the video tape he says something to the effect that so often we forget in our relationships with each other that the more positive our relationship is, the more successful our relationship is. He uses an example of a newly married couple. They're in a restaurant, and they're leaning close to each other and hanging on every word, and the husband says, "Oh, boy, I love that dress on you, my Lady in Red." And then you look in that same restaurant and you see a couple who's been married twenty-five years, and they hardly have anything to say to each other. That's because they have eliminated so many opportunities to be positive with each other. So, if you'll try that same psychology working with your clients, you will make things easier. You will make things upbeat. You will make things fantastic every time you interact with them — they're going to want to interact with you as a friend, as a true art consultant not as a salesperson.

Now, another thing that's important about this is that in addition to the rapport-building aspect is your knowledge. In other words, on the one hand, you will become, and I'm sure you are, very dear friends with all of your clients. But you also have to have some good information to share that distinguishes you as an art consultant. This is where a lot of people fail. I'm not talking about being an expert in art history. I'm not talking about having browsed through galleries throughout Europe, necessarily (if you haven't already). I'm talking about honing your craft knowing about your artists, talking to your artists, finding out what their inspiration is. I'm talking about the passion, the spiritual connection between the art work and the world.

My clients in my home state have become so famous for having art consultants who make a ton of money that a lot of people come interviewing for jobs, calling the sales managers saying, "Hey, I want to work for you because I heard you live in paradise and make a hundred-thousand dollars a year. I can't wait." And sometimes

these people are not really sincere about working very hard, and they come in, and we take them through the course. Then they see the information that they have to study about the artists, and it overwhelms them. We make them study only ten artists, and yet, we're talking about information that's going to take many hours of study. We test them on it. I tell you, before that test comes around after just four weeks into it, a lot of people decide not to take it. And this is exactly what happens on the floor. They think they can wing it. These people with the gift of gab think they can just sell anything.

CONSULTANT: "Well, hi, how are you? Yeah, I know how to greet people. Yeah, c'mon in. Welcome to our gallery. Oh yeah, you like that piece. Fantastic. Let me take you to the closing room." And they set it up there and say, "Well, gee, Mr. Collector, I'm curious, you like that, huh? What do you like about it? Great." Then they have this pregnant pause, this void, and they wonder why the people inevitably do this:

CLIENT: "Thank you very much. You've been really helpful. Do you have anything in writing that I can read about it, and I'll let you know."

CONSULTANT: Yeah." They grab the brochure, staple it to their card, and they sign them up because they hope — they all hope — that if the person ever does buy anything, maybe they'll get a piece of the action, a commission split.

Remember, you are spending an hour and a half, and there's only so much you can say to people. After a while, you get to know their life stories, and they get to know yours. And what have you really accomplished? You want to be in a position of saying:

CONSULTANT: "Have you folks ever acquired a fine graphic before?"

CLIENT: "Well, no, we've only acquired originals."

CONSULTANT: "Fantastic. Well, do you think you might like to get one of the originals? They run about thirty-five-thousand dollars. Does that feel comfortable?"

CLIENT: "Oh my God, we've never spent that much for an original piece, but, you know, we have a wonderful collection. We collect this and that."

CONSULTANT: "Fantastic, well why don't we go ahead and show you some of the fine graphics? You've mentioned you like this piece."

CLIENT: "Isn't that an original?"

CONSULTANT: "I'm really excited. A lot of people think that his multiple works are originals. Can I tell you a little bit about the science and the technique that goes into making a work like this?"

And then you describe the iridescence and the mother-of-pearl coating on fully archival paper that will last forever. It will ultimately become a family heirloom. "This is a mixed-media graphic. Do you know what that means? You normally buy only original paintings. Can I share with you what that means? Can you see how it's raised and has embossing? etc., etc."

What we're going to do is really exciting; we're going to take a look at both aspects of rapport-building: the emotion and the technical information. We'll take a very strategic look at it so you can incorporate it into your sales presentation.

The Sales Presentation

There are two vital components of the sales presentation: (1) the logic, and (2) the emotion. Many experts believe that ninety-five percent of our decision-making is emotional and only five percent is based on logic. In fact, most people seek a rationale to justify an emotional purchase.

Logic

While it may be less important for a client in formulating a decision, logic is critical to keeping the person from slipping into "buyer's remorse" and later canceling. Every art consultant must have critical information at his/her fingertips to share with clients. What precisely is pulled from this databank depends on the client. To cover most bases, study these categories of information on each artist you sell: (1) Style and Technique, (2) Background and Credentials, (3) Appreciation History, and (4) Major Collectors and Awards.

These four categories of information (LOGIC) must be carefully woven throughout the second vital sales presentation component... the emotion.

Emotion

The professional art consultant knows that clients emotionally "connect" with their art, and the best way to sell art is to help people discover their emotional attachment to it. But how do we consistently and methodically do this? We become astute "people readers."

Reading Personality Styles

We each have distinct ways of thinking and feeling that are based on a whole host of work and life experiences. This individuality represents who we are and determines how we behave and interact with others.

As professional art consultants, we notice in our day-to-day interactions that while some people enjoy "joking around" during the selling interaction, there are others who become easily offended by any digression from the business at hand. Similarly, some clients prefer bottom-line, direct, lengthy elaboration of every detail. We may take notice of these obvious differences in people, but what can we do to use this information to make our selling interactions more successful? This section will explore the concept of "people reading" for more effective selling.

HOW DO STYLES AFFECT YOUR SELLING EFFECTIVENESS?

HAVE YOU EVER LOST A SALE BECAUSE:

(1) You failed to establish rapport with a client?

(2) You tried to establish rapport with a client?

(3) You were not "speedy" enough in getting all the proper paperwork together?

(4) You invited clients to come back after they "thought about it," but they never returned?

(5) You could not "convince" them even though you just "knew" it looked great and was affordable?

Well, if you answered "yes" to any one of the above, there's a good chance "people reading" can improve your selling effectiveness.

Most psychologists agree that we all take in information from simple observations of others' behaviors. Many people, in fact, strongly believe that some of us are intuitive in self-awareness observation. With just a little practice, any art consultant can become

a better "people reader," and in so doing any art consultant can begin to realize greater sales levels.

If you cringe at the thought of spending time and energy "to be more in touch with others," you may need to reconsider your profession. Make no mistake about it; selling is a people business. If you are not interested in people, you are not interested in selling.

PEOPLE READING FOR POSITIVE CONTROL

The professional art consultant knows that how we buy is how we tend to sell and vice versa. In other words, if we like direct answers and no "joking around" during the selling interaction as the buyer, then that is how we tend to treat the bulk of our clients when the shoe is on the other foot. Well, this would be fine if everyone was just like us. If the contrary is true (and of course it is), then we see immediately how this selling approach would limit our successes to either blind luck or the fact that the customers who bought were very similar to ourselves.

It doesn't take long to figure out that if we want to significantly increase the likelihood of making more sales, then we should begin by first studying ourselves and then studying those around us.

The professional art consultant knows that to be successful we must:

(1) Know ourselves our own buying and selling motives.

(2) Study the clients - their buying motives.

(3) Modify our behavior - to make the client most comfortable and receptive.

(4) Stay in positive control of the selling interaction by being flexible in our behavior.

Many experts find it useful to explore business relationships using a straightforward four-pronged model. For our purposes, I have labeled these personality categories: Directors, Thrillers, Thinkers, and Analyzers.

DIRECTORS: Strong, directive, verbal personality with high ego strength. Makes quick decisions. Handles self well in unfavorable situations.

THRILLERS: Strong, positive, verbal personality that is emotionally charged. Makes impulsive decisions. Handles self well in favorable situations.

THINKERS: Mild mannered, less verbal personality. Makes thoughtful decisions. Handles self well in favorable situations.

ANALYZERS: Skeptical, less verbal personality that appears unemotional and reserved. Makes decisions based on detailed factual information. Handles self well in unfavorable situations.

IDENTIFYING YOUR CLIENTS TO MAXIMIZE SALES OPPORTUNITIES

DIRECTORS
1. Bold & Outspoken

2. Quick Decision Makers

3. Bottom-Line Oriented

4. Change Agents

 COLD: Disagree — FACE: Cool, Slight Scowl

 HOT: Give Respect — BODY: Pompous

THRILLERS
1. Friendly

2. People Oriented

3. Impulsive

4. Disorganized

 COLD: No, I don't like you! — FACE: Smile

 HOT: Give Admiration/Love — BODY: Free & Sharp

THINKERS

 1. Think About It

 2. Family Oriented

 3. Soft Spoken

 4. Loyal & Routine

 COLD: Abruptness — FACE: Neutral/Pleasant/Bored

 HOT: Trust, Empathy — BODY: Conservative

ANALYZERS 1. Data

 2. Detail/Meticulous

 3. Analytical

 4. Change Stopper

 COLD: Criticism — FACE: Upside Down Smile

 HOT: Explanations — BODY: Rigid/Proper/Stiff

THE *PEOPLE READING* SALES PLANNER

DIRECTORS

Remember:

Provide DIRECT answers.

Person wishes to make a quick decision; quicken your pace.

Provide them the pros and cons of owning the art work.

Tell them that you respect their opinions.

Encourage them to consider the prestige, freedom, and authority the art work will provide.

THRILLERS

Remember:

Smile and appear friendly, open.

Chitchat before handling business (as time permits).

Person makes impulsive decisions.

Provide "exciting" reasons for acquiring the piece.

Tell them that you like them as a person; flattery is appreciated.

Encourage them to consider the fun, popularity, flexibility, and innovativeness the art work will provide.

THINKERS

Remember:

Slow your pace (unless you are a THINKER).

Establish a rapport; discuss family issues.

Person makes thoughtful decisions.

Provide practical reasons for getting the art work.

Tell them that you appreciate their business.

Encourage them to consider the investment, security, and peace of mind.

ANALYZERS

Remember:

Stay away from emotional words.

Stick to the facts; get detailed.

Emphasize the operational integrity.

Person makes factual decisions.

Tell them how much you appreciate the importance of precise procedures.

Encourage them to consider the value, quality, and precise detail the art work will provide.

If we pay attention to our clients' emotional needs and their special ways of making decisions, we can tailor our sales presentations for greater results.

This four-pronged behavioral model can come in real handy when you're trying to figure out very quickly, how can I get in step with this business person? How do I immediately establish a rapport with someone I've never met before? This four-pronged model uses visual cues that you all pick up. In fact, many experts believe that we formulate our decisions about people in the first seven seconds, often before the person even utters a single word. How do you capitalize on this information that you already have? That's what this is all about.

Directors

First of all, there is a category of people who are referred to as Directors. Director-type people (you can spot them when they walk into a gallery) act as if they own the place. They act as if they are the gallery director. They walk in very presumptuously and as if they owned the place, and they usually have a critical look on their faces, and they usually say things like, "Oh, uh, why do you have this set up this way? The gallery is too dark." And they have to say something that quite often the rest of us would think of as rude and obnoxious, but that is just their way. They're totally outspoken. They tend to think critically. They're bold and outspoken. They are bottom-line oriented. They're the ones who say, "Hey, don't give me a sales pitch. I know you're trying to sell me this."

Quite often, my knee-jerk reaction is to go on the defensive with these people and do the exact opposite of what they need. What we're going to discover is that, for all four basic personality styles, our knee-jerk reaction is quite often the opposite of what the people really need to get into the buying mood. So, when Mr. Director comes in and he puts us on the defensive, we fall right into that trap, unfortunately, right? Our knee-jerk reaction is to back off or to tell Mr. Director to,"Get out of the gallery, you S-O-B!" Exactly!

We have this ego struggle right in the gallery. You wrestle and guess who loses? You do! I get a lot of that. In Hawaii we call the bottom, the rear-end, the okolei. Many of my art consultants, when they get to this part, say, "Oh, so you want me to go around kissing on okoleis, huh?" And I say, "Well, if you see it that way, there's nothing I can tell you. But I share this with you — if you do the right thing, put this person in the buying mood, then who is really in control?"

"You are."

Absolutely. Absolutely. Often we women know that when we're dealing with our husbands, our business partners, or whatever, many times we have to make them feel as if they're the ones in control, but in actuality, who is? We are.

I'm not talking about being manipulative or back-stabbing or anything like that. We're talking about positive control so that we can move forward. I'm not talking about something sneaky and subversive.

These Directors are quick decision-makers. They're the ones who will put you on the defensive. Let me tell you what their faces look like. They have a slight scowl. They walk in, and it looks as if they have a slight sense of disapproval as soon as they come across the threshold. Their bodies are pompous. It's as if, in a former life, they were kings or queens, and they don't want you to forget it.

I'm going to be real candid about my comments because I think this situation is so important for you. Often people think I'm too hard on the Director type. My husband is a Director type. He wears a social mask many times (we all wear different masks), but in his natural habitat, if you will, his business way of communicating is definitely the Director type. Ego struggles can happen any moment. The sparks can fly, especially if you get another unsuspecting Director type. So, obviously, I love the Director type. In fact, when you read between the lines on how I express myself, you will figure out what I am. I have a very strong Director in me. I'm in control.

Let me tell you what their Cold and Hot buttons are. In fact, I'm going to give you their ironic question to the world because what I've discovered is that each personality style presents itself to the world in an ironic way. In other words, Ms./Mr. Director gives the impression of being totally in control, of wanting to give you the sense that s/he doesn't have any questions and doesn't need to be taught anything — knows everything about art work, etc. In actuality they're not quite that way, and it goes something like this. Says Ms./Mr. Director, "I'm hot... aren't I?" When you really get into this heavily (I do a serious program on this with my client management teams — we improvise the psychological makeup of each personality), it becomes very easy not to think about personal things. You realize that you have real deep-seated psychological needs. You think about you, as an art consultant out there on the floor. Very quickly and very easily, without costing you a penny, maybe a little bit of time, you can satisfy a person's deep-seated psychological needs. It's glorifying. Do you know what the Director types need? (Our knee-jerk reaction to the Director type is to say "no" to their questions, right? "You S-O-B, get out of my gallery." We say, "Who do you think you are? No, you aren't so hot. Not in my book, anyway.") But the Hot button — the thing that gets them in the buying mood — is just the opposite. We say, "You know what, Ms/Mr. Director, you are hot stuff." The first thing I do with this business type when he walks in and doesn't have any time and patience is walk right up to him and say:

CONSULTANT: "I bet you own your own company, don't you?"

CLIENT: "Well, as a matter of fact, I'm starting one. Right now, I'm a systems analyst with X-Y-Z firm..." — or, they'll say:

CLIENT: "Well, as a matter of fact, I do. I work at X-Y-Z company to pay the mortgage. But I happen to have my own consulting service. I'm the President of my own consulting service on the side."

CONSULTANT: "Oh, well do you have a lot of employees?"

CLIENT: "Well, it's just me right now, and, as a matter of fact, I am President."

Always, no matter where they are, they think or *want* to think that they are on top. Let me give you some hot tips.

HOW TO GET THEM IN THE BUYING MOOD

They are bottom-line oriented so you want to keep your sales presentation short. If you're verbose, like I tend to be, you shorten it way up. With the Director types you want to give them direct answers. If they say, "How much is this?" you don't beat around the bush at all. You say, "This particular piece is fifteen-thousand dollars. How does that sound? Do you like it? Great, well, why don't we go ahead and wrap it up then? You don't like it? Well, why not? You walked right over to it." Say it with a strong voice. You punctuate what you have to say.

The other key thing that you want to remember, in relation to selling fine art, is, you've got to realize that this type of person does not buy "things." None of us buys things anymore. In most parts of the world today, the industrial world anyway, we don't buy things. We all buy what's important to our psychological needs. That applies even to those of us who think we're buying a car. That was illustrated with the Mercedes we talked quite a bit about. We aren't really buying a car — a mode of transportation. What are we buying? Prestige — and that's what Ms/Mr. Directors want. So, when you're selling fine art, you're going to emphasize the prestige.

What else do the Director types buy? Luxury. They buy convenience in other words, they are so impatient that they don't have time for anything. So, you might say:

CONSULTANT: "If I can make this easy for you, then let's go ahead and go for it, OK? There's no reason not to. It won't take any of your time. I'm going to take care of it. Don't worry about it."

Freedom is another way to put it. So, when you say things like, "The people who collect Hisashi Otsuka include Sophia Loren, Brooke Shields, The Governor of our State — people with unlimited resources like yourself; you're in great company," they respond well.

Thrillers

The reason I call them the Thrillers is that they're thrilled with everything. They walk into the gallery and say:

CLIENT:	"Oh, boy, I'm so excited. I love everything."
CONSULTANT:	"Do you like any particular piece better than another?"
CLIENT:	"Oh, I love everything. I could have everything."
CONSULTANT:	"It's so beautiful."
CLIENT:	"Oh everything is so beautiful. I'm so excited. Bring that one in the demo room. Oh, I have all day. In fact, let me tell you my life story, and when I'm done, I want you to tell me yours."

They're silly, and they're fun people. In fact, one of the things you want to remember is that they're overly friendly. When they walk into the gallery, they have a big animated smile, and they say, "HI."

These people are people-oriented. The other thing that really messes them up is that they are impulsive, and I'm going to use the term "disorganized." They love everything, and let me tell you what their faces look like. I've already alluded to a big, animated smile, totally uncalled for, but their neutral expression is a big smile. Let me tell you what their body looks like. They tend to be what I call free in their body language. They walk in free-flowing, and the other term I like to use is "sharp." That's relative — sharp in terms of pulling themselves together (i.e., looking sophisticated, in some cases; in other cases it would be a certain level of attractiveness). They're the type that goes to a hairstylist to get their hair cut. They would get a manicure versus doing it themselves. They're the ones who tend to wear jewelry, although you've got to watch out for them. They'll wear fake-it-till-you-make-it jewelry because it's the illusion that matters.

You've got to watch out for them. They're the Z Queens and Z Kings. In the resort towns, they're the ones with the designer shorts, and they would never be caught (even after they've gone to the beach) with their hair wet. Now, let me tell you what

their ironic question is through all of this: "Life is great. I'm lovable and adorable, aren't I?"

They seem a little transparent or superficial. That's how some of us who have a bit more gravity in our personalities might react to people like that. You just can't believe the bubbles — bubbliness is for real for such a sustained period of time, and to be so excited so much is so unrealistic for those of us with gravity in our personalities. Because I'm not spending much time, I can't give you a real strong sense of the deep psychological needs of these people, but, by and large, many of these people had some really serious things happen in their lives. Many were manic depressive, especially when they were younger. They have these tremendous mood swings where they are on top of the world — and that's when they're out in public and they don't come out when they're down. Their highs are really high, and their lows are very low. As they get older, their swings are less severe, but their showmanship what they show to the public — remains that bubbly type of personality. But basically they project: "Life is great. I'm lovable. I'm adorable." They want constant reassurance that they're lovable, adorable, really fantastic — while the Directors want to be reassured that they deserve respect — because they're not so sure. The Thrillers want to be assured that they deserve love and admiration — and guess what? They don't buy cars. They don't buy fine art. What do you think they buy?

They buy popularity. You say things like, "If you buy this Hisashi Otsuka piece, you're going to be the first person on your block to have one, but all of your friends are going to be amazed. Isn't that really what you're looking for? Dinner parties. Think about it." You're going to tell them about the mother-of-pearl iridescence, the arduous training, and they're going to be so impressed. Now, if you embellish this with the Director types, you're up the wrong stream without a paddle. You're in the wrong boat. What else do they buy? They're the ones with the red sports car.

The Thrillers will buy from you because they get the sense that you "love" them. They'll say, "Oh, I'm just dealing with so and so. Every time she calls me everything is fantastic. If I don't pay on time, she doesn't get mad at me." That's right, one of the things you can add as a footnote to this is to remind yourself: because they're disorganized, when you make commitments with the Thriller types, you've got to be prepared for the fact that they have no sense of time, and they have no sense of formal commitment. Daytimer calendars and that sort of thing do not relate to their personalities at all. So, if you say things like this to the Thriller type:

CONSULTANT: "Why don't you come back tomorrow at three o'clock?" - forget it. You're setting yourself up for disappointment. It goes more like this:

CONSULTANT: "While you're here, why don't we go ahead and do the paperwork on this?"

CLIENT: "Well, I'm not sure if I have any money in my bank because while I was here, you know I overspent every cent."

CONSULTANT: "I'll tell you what. Why don't you go ahead and give me a check, and I'll run it through the bank, and if it doesn't go through, I'll hold on to it for a week, give you a call, and when you're ready for me to send it through, I will."

Do you see the difference? In other words, you've got to be first in line on payday. Now, if you get a Rich Thriller, good news! But for most Thrillers, you've got to make it real easy for them, and be real patient and understanding and everything is fantastic even when they disappoint you. And you'll have a good Thriller client for life. Other art consultants will immediately throw them out of the gallery when they disappoint them the first time. So if you think about it, I'd rather get it two weeks late versus not at all, over a lifetime. As long as you have that attitude about it, you'll be fine with them.

THE RICH THRILLER

CONSULTANT: "You know, I'm really excited. You love everything in the gallery. I know you do. Why don't I come to your Malibu Beach home? Why don't I just fly out next week? Are you going to be there? Well, I'll call just before I get my plane and make sure that something hasn't come up. I'm going to bring some paintings, and we're going to outfit your place, OK?"

And, as far-fetched as that sounds, one of my art consultants at Lahaina Galleries ran into a wealthy lady like that, and that's exactly what she did. I won't mention the client's name, but she basically loved everything. Other people couldn't cope with her. Mary Ellen says, "I'm going to be in the Los Angeles area next week." She had no plans to be in Los Angeles, for she was just starting at the time. This was a gutsy thing for her to do just because she was fairly new and didn't have much in the way of savings. She took her savings and bought that ticket. Do you know what happened? This woman, who is very famous and very wealthy, had Mary Ellen stay with her in her Malibu

Beach home, and this woman bought a hundred-thousand dollars worth of art work in one week!

Well, that particular firm at that particular time offered a ten-percent commission, plus there was a bonus, so she got a little bit more. Don't you think that was pretty nifty for a week's work? I'd like to see how much money she's going to make in the future. It will no doubt be a mint.

The Thriller is also the one who, once she buys from Zella, regards Zella as "the only one to deal with because she is so super."

That's right. They will embellish it to the point where you're walking on water. In a sense, if they're well-to-do, you can get incredible referrals. They have credibility by virtue of their wealth. Isn't that interesting? As a review, the key things to remember when working the traffic are: You want to qualify them early because you could end up wasting three, four, five, ten precious hours on someone who's not going to buy anything, ever. And you've got to do it in such a way that you leave the door open. I'm a firm believer in that because someone who may be struggling today may strike it rich tomorrow. I've seen it happen so many times that it's almost unbelievable, and it goes like this: You spend that nice twenty minutes or so (no one else is in the gallery, and you're kind of watching the door), and you're having a great conversation. You're trying to focus them, but you can't and you qualify them with two or three or five questions and finally, someone walks in, and you say, "It's been a pleasure talking with you. I can't tell you how delighted I am to have met you. Would you be so kind as to put your name in the guestbook? We'll stay in touch, OK? So sorry to hear that you got laid off from your job last month. When you get some time, you can stop by after we close. We're having such a great time chatting that maybe we can chat some more then." By doing it that way, they always feel welcome, but you're doing it in such a way that it's good for you too. You're not sacrificing valuable time.

Thinkers

Let's go to the next category — the Thinkers. Just as you might imagine, the Thinkers make up the majority of the population. Many psychologists believe that these people make up something like sixty percent of the population in America- even higher in places like Hawaii. They think; they deliberate. Two things that you can see or spot in the Thinkers in the first seven seconds include: they are soft-spoken and observant people; their psychological characteristics include a tendency to be very loyal and routine. Do you know what routine means? This is something that we overlook. But you can count on it. They are the ones who you want to set up your layaway accounts with. They can make or break your business. They are people who, once they fall in love with

a piece, are going to take that credit and they're going to pay that hundred dollars a month, for a year, or for however long it takes. That's right, forever. They are very worthwhile risks. They are also family-oriented, and this is something you'll want to keep in mind when you want to develop rapport. The fastest way to develop a rapport with a Thinker is to say, "Ah, how are you? You know, it's so nice to meet you. I'm really glad you came in. Did you bring the kids with you? Well, what school is he in?" They love it when asked about their children. Ask them to show you photographs... they will.

I have identified three neutral expressions the Thinkers wear: neutral, pleasant, and bored. The neutral expression is a rather sedate look. The pleasant look is often expressed by Thinker women. They have an "Oh how Pleasant" look on their "nice" faces. The third expression a lot of the Thinker men have. This will throw you off, but a lot of the thinker men look utterly and devastatingly bored. The reason this will throw you off is, your knee-jerk reaction to this is to do the exact opposite of what these people need. If you think people are bored, what do you want to do?

"Get them excited."

You may excite them, or worse, disengage, because you think, "Gee, they're not listening."

"Uh-huh."

This is a neutral expression. This is what they present to the world. This is how their face is.

"I've noticed at times a couple will come in. The wife is thrilled and excited about everything in the gallery, and the man will plunk himself right there on a chair and sit there, and let her browse, 'You want it? OK, fine. Buy it. I'll wait in the car.'"

Yeah, I know how that is.

"He'd rather wait in the car. How do you get a guy like that excited?"

You don't have to.

"The wife is doing all the work."

That's right. You don't have to. Remember the thing about finding out who's the decision-maker? If it's that obvious, don't even put yourself out! The husband (Mr. Thinker) is not looking for excitement. From his point of view, living with a Thriller is enough excitement!

Let's review what the Thinker's ironic question is, and the Cold and Hot buttons will become obvious. Because they're so family-oriented, because they're so conservative, because they want desperately to become rooted and loyal to something, this is their message: "I can trust you. I can trust you, can't I? I want to. I'm a loyal, routine person. If I have a formal relationship like I want to have with you, you have to understand, I'll buy all of my art work from you forever." You have to understand their deep-seated psychological need. "I want to align myself with you, Steve, because you're the owner of this place, and you're going to be around for awhile. You're not just in this for the money, are you? I can trust you as a human being, and, if they ever sell this place, and you go somewhere else and buy another gallery, I'm still going to buy from you, Steve." We are absolutely together, and that's what the Thinker wants.

That reminds me of a favorite story that I'd like to share with you. Larry and I live in the suburbs of Honolulu, and sometimes when I want to get into town, I use the bus. In Honolulu, you can't flag a cab the way you do here. I ran into this gentleman on the bus, and I started chatting with him, "Hi." I saw he was a Thinker, and we sat down, and I said, "Are you visiting here in Honolulu?" "Yeah, kind of." I looked at what he had on and said, "You're attending a convention, aren't you?" "Yes, I do every year." "Is that right?" "This is my twentieth year, and I come here every year." I said, "Is that right? Where are you staying?" "At the Sheraton." "That's nice." "Oh, yeah." I said, "Have you ever stayed anywhere else?" "No." "In all the times that you've come to Hawaii, have you ever visited another island?" "No." I said, to myself, this is a Thinker if I've ever seen one. "Have you got any pictures of your kids?" This is my reaction from the word "go" to someone who is a Thinker. Isn't that something? Now, it just so happens I'll finish the story. He got really sad when I asked that. He didn't have any kids. I thought, "Hmm. Maybe I'm wrong about him." And I said, "You know, maybe your wife?" "We just got divorced." And he was so sad, he said, "Let me show you — I've got something to show you." He took out his wallet, and he showed me twelve color photographs of his house. "This is the front yard. This is my family room. This is the fireplace I had put in last fall." These people are rooted! They want to be loyal and deeply related, and so on, with tradition. Based on all of that, guess what they buy. I just used one of the words.

"Tradition." When you want to get that concept across to the client, you use statements like the following:

"This is traditional art work. You can't get any more traditional than this; this is a family heirloom; this is destined to become a family heirloom; this is something that you can pass down to your children and your children's children."

"Quality" becomes important from the standpoint that it's going to last.

"Value" is thought of from the standpoint that it is a reasonable investment. Value has different meanings. This is something that is an investment. You can educate them on what that word means, as we've already talked about. From their standpoint, it's like an antique or any other fine collectible, which is music to their ears. This is a real, hard asset. They like the fact that it's not a liquid asset. We're not talking about the Director types, you know. They're impatient, and they want things to be fast and quick. We're talking about someone who wants to be your client for life. They repeat. These are our clients who, year after year, plug away and buy another work of art.

In other words, because they are Thinkers, they're the ones who are going to tell you each and every time, "You know, I really have to think about it," after you invest that hour and a half or two hours in the closing room. They are worth the follow-up. With sixty percent of the population, you have to have some kind of strategic, organized way to follow up with these people. Because, if you do, it's going to mean so much to you. They're the ones you want to send Christmas cards to — anniversary cards, et cetera, et cetera. These people want, more than anything else, a trusting relationship. They make up such a big part of the population. They're the ones who want you to service them well. And here's something that's music to their ears, that they hardly ever hear because they're the soft-spoken ones who never complain: "I appreciate your business — I just want you to know. I really appreciate your business." Tell them that. Set the stage, as we've already discussed, and that's where you get all your referrals. And so, the Cold button is pushed when you say "no" to the question, "I can trust you, can't I" with body language and facial expressions. One of the easiest ways to turn a Thinker off is with abruptness. What happens is, because they tend to be rather slow in delivery and movements, and they're thoughtful in their decision-making, a lot of us who are not Thinker types, or who are trying desperately to earn an income, are not patient with these folks. We are impatient, and, therefore, we lose them.

The majority of the most wealthy people fall into this category — not because of sheer numbers, but because of the personality type. The reason is that we become more and more conservative as we become wealthy. Even the so-called celebrity types — once all the splash and flash has died down, with maturity and being accustomed to wealth, they become more conservative. It also becomes more important to them when they have children. Also, many people who are wealthy in this country have inherited their wealth, and one of the reasons why their forefathers and their foremothers worked so hard was to create a dynasty. They did it for their children who are now reaping the benefits for real. Interesting, isn't it?

"What is their body like?"

Their body language is conservative. They also tend to wear dull colors. They like browns and tans because they don't want to stand out. That's their whole motif. You give them time and space to adjust. You say, "Well, how much time do you need? I know you've got to think about it. Of course. I really admire people who make thoughtful, deliberate decisions." When you really get down to it, most people are that way. My Thinker factor is getting higher as I get older. So, you give them a lot of time to adjust."You need time? How much time do you need? No problem." When you tell them, "I'm going to call you at three o'clock on Friday," you call because they're going to be sitting at the phone at fifteen minutes to three waiting for your call.

Analyzers

Last but not least, we have the Analyzers and they, like the Director types, can be difficult for some people to handle. They represent the smallest percentage of the population so I won't spend a lot of time on them. Just as their descriptive title implies — they are analytical.

They are detailed and meticulous. They value facts and things in writing. Let me tell you what their faces look like. A classic Analyzer wears what I call an upside-down smile.

In Hawaii I can always point to our former Governor, Aryoshi, as an example of a classic Analyzer. His face is very unapproachable. Some people ask me, "Aren't they grumpy?" No. They just look that way. The Directors look unapproachable too. On the other hand, the Thrillers look very approachable. They could be experiencing the worst in their entire lives, but that's not what they show the world. They reveal neutral expressions. These faces I'm describing are the faces clients walk in with over the threshold. It's the neutral expression they present to the world. What you have to understand is that what it appears to be is not necessarily what you should interpret. It's just a neutral expression. The Analyzers' bodies are rigid and proper. They don't move too much. They do research on buying. They're the shoppers. They shop around like you wouldn't believe. I'm not talking about browse/shopping. The Thinkers browse/shop. Thinkers go off, and they're not really thinking about it. They're just browsing. Then they're reinforcing for themselves why they want to do business with you, and they just need the time to mull it over. The Analyzers, on the other hand, are out there shopping. They say, "How much is that?" And you say, "That's fourteen-thousand nine-hundred and fifty dollars." "Is that the best you can do for me? Are you competitive?" "Yes, yes." And then, they go down the street, and they see what they believe is identical or similar, and it's fourteen-thousand four-hundred fifty-two dollars and thirty-eight cents. They have a little book, and they write that down. They're going

to decide that they're not going to buy from you because you have misrepresented the facts. That's how they would word it versus, you lied — or they were insulted that you lied to them. It's, "You misrepresented the facts. You run a schlocky organization down here. I'm not going to bother with you. How can I count on you?" It is not that they can't trust you. You just don't run your operation properly.

"What's the ironic question?"

The ironic question is, "The way it is, is best, isn't it?" In other words, if you tell me that it's fourteen-thousand nine-hundred fifty-eight dollars and thirty-eight cents, and that's the best you can do for me, and you're competitive, you're going to give me a certificate of authenticity to that effect immediately when it arrives, and those things had better happen. And if they don't, then I'm going to be really disappointed.

In other words, they need you to be precise with them because they value detail greatly. They have relied on "research" as a way of life and need you to reinforce their carefully researched opinion — because they really are not so sure of its correctness.

One thing you should never do with an Analyzer: "wing it" — especially those of us with the gift of gab! If they say, "How much is that?" and you don't know for sure, don't ever do this: "Well, that's around fourteen thousand." They'll go right out the door. "What does that mean?" Rather — let's say you look, and the price tag is gone. "I have to tell you that, unfortunately, when they rehung the gallery this morning, we overlooked that, and I can't tell you how embarrassed I am, but I can go to our catalog. Have you got a minute? I can look it up for you. Or do you want me to ballpark it for you? I can give you a range right now, and then you can see." See the difference? "Well, give me a ballpark figure right now, and then I definitely want you to go check the exact price and write it on your card so I can take it with me." "Oh, OK." Now let me give you the Cold and Hot buttons. The Cold button is pressed when we criticize this analytical behavior. We may be tempted to say, "Why is it so important that I tell you exactly to the penny?.... How much is shipping?" "Well, I don't know, a hundred and fifty dollars, or thereabouts." "Well, I want to know exactly how much it is." "Well, why do you want to know that?" kind of criticism turns them right off. It's as if they are saying, "I can't count on these people." On the other hand, the Hot button is pressed when we give many explanations.

I'd like you to visualize a scale. The Analyzer usually walks in with a ton of rocks that weigh the scale down with his opinion. The only way that you can change that Analyzer's opinion is to very strategically remove pebble by pebble, slow but sure — it's not about time; it's about information; it's about details to persuade the person to your point of view. As a matter of fact, the best way to close these people is on a conditional

sale. Be prepared for cancellations in case you don't know enough about your competition. Assure them that the condition is a hundred percent. So, it goes like this: you reason with Analyzers. That means that you're going to have to spend a lot of detailed time with them. You know you want to show them things in writing, but you don't show it all at once; you pace it out. "You know, you seem like the kind of person who really appreciates details, don't you?" "Yes, I do." "Well, as a matter of fact, I have something in writing in the back that I want to show you. Why don't you go ahead and admire the piece. I'll be right back. Remember I mentioned the collectors a half-hour ago or so? Well, here's a whole list of them in writing. Remember I mentioned," and you take that pen. "Isn't that important to you?" "Oh, it is. Yeah. OK, great." Anticipate that when you go for the close, they're going to say, "Well, why don't I take this home, and I just want to make sure everything is in order, and I'll let you know." Anticipate that. Your knee-jerk reaction has got to be, "You know, why don't we go ahead and do the paperwork on it?" "Oh, no, I've got to make sure that this is in order. I'm going to call my accountant and then my CPA and make sure you folks have the right business license and determine how long you've been here. You've been here five and a half years is that five years and six months? OK — and that you have a degree in fine arts — I'm just going to check the information." "Now, let me ask you something, sir. If you were convinced that everything that I shared with you is on the up and up, and all the detail I've provided you with is sufficient, is there anything else holding you back? I mean, you love the piece, don't you?" "Yeah." "I tell you what, why don't I go ahead and do the paperwork and then, if for any reason you decide that you can't count on us, let me know, and we'll make arrangements. Why don't you go ahead and do it?" They'll typically respond quickly, "So, in other words, if I'm dissatisfied — ." "Absolutely. Absolutely." "You're sure about that: What if I have to ship who's going to take care of the shipping?" "We will." Or whatever your policy is — and you'd better follow up on that. That's how you handle them. One caution here: When you close an Analyzer on a conditional sale (if you're dissatisfied, then we will return your money), be prepared for a certain number of cancellations. Remain confident, however, that the total number of sales will increase.

Remember, the Analyzers and the Directors are the ones most likely to buy today — if you follow the preceding tips. If you remember nothing else about what I've shared with you, remember this. When the least approachable walk in, you want to leap out of your chair and hang up the phone because if you play it right, you're going to make some money. On the other hand, these approachable folks are going to take work. They take work, time and strategy, and yet they're the ones who we tend to spend all our time with! Isn't that something? When we see that unapproachable person, we kind of glance over and want to get that nice, little smile, and we never get it, of course. They

walk in, and they walk out. And we say, "Oh, well." And the person we're talking with takes up our time, and they walk out and don't buy anything. So what do Analyzers buy?

"Credibility and precision." In other words, they're the ones who are impressed with the fact that you say you ship on time. "If you have one tiny, little scratch in the frame, no questions asked, we'll take care of it." They're the ones who are impressed with, "If we tell you it's going to take three weeks, it'll be three weeks or less." They also buy, but differently. They buy value from the standpoint that, factually speaking, it's the best you can do for them. They buy quality from the standpoint that you run a quality organization here. The graphics are done with the utmost care. Your artist spends fifty hours to do the sky. Therefore, what they need, more than anything else, is factual information.

What Determines Great Art?

This question has been posed through the ages. Why do we travel to Paris, go to the Louvre and view for only a few precious moments — the Mona Lisa? Why do we find ourselves so fascinated with the great pyramids of Egypt? What makes a Robert Lyn Nelson painting of the two worlds so compelling? In many ways, when it comes to great art, we are more captivated by the questions they raise than by the answers they provide us.

A few years ago, I invited Martin Issacson, a lecturer at UCLA on art interpretation, to come and share his perspective on great art at a couple of my public seminars. He expressed that all great art has the big MAC: Mystery, Ambiguity, and Contradiction. This really stuck with me and my clients. Just for fun, we even had buttons made up with the Mona Lisa in the center with the following words circling the perimeter of the button: Mona Lisa has the big MAC! What Isaacson was stressing was what most of us already knew, and that is, great art transcends the obvious.

For example, what movie stands our in your mind? The one that plods along predictably? Or the one that a dozen people see, and each one "sees" something different? What people are we most fascinated with — the ones who bore us or the ones we fail to fully comprehend? This holds true for so many of our relationships that we have coined two often-heard phrases: "opposites attract" and "familiarity breeds contempt". Our thirst for challenge appears unquenchable when it comes to the exciting "chemistry" between ourselves and our lovers, ourselves and our art.

In addition, the archetypes within an image speak to the collective subconscious and provide persuasive fuel for the knowledgeable art consultant. What do mountains

in a painting say to any onlooker, whether you ask a 16th century peasant or a 20th century businessman? Why have we adorned ourselves with gold and precious stones since the dawn of humankind? Doesn't a mountain mean "mother earth", strength, and power? Don't gold and precious stones mean permanence and immortality? These interpretations transcend time, culture, and class. In a sense, we are all one and possess a collective consciousness that gets passed on through our genes just as surely as we give our children their eye color.

Thus, when we examine a great work of art, it literally moves us on many levels: visually, emotionally, and spiritually. Some of you might be surprised to learn that a clinical condition exists called the "Stendahl Syndrome" which leaves some viewers of great masterpieces feeling faint. Those stricken with this condition have a difficult time staying composed while in museums. They sometimes lose consciousness and must be removed from the premises. Happily, only a small percentage of the population need to be concerned about fainting when near great art. However, be assured that all of us are moved by great art to some degree. It is the art consultant's role as the facilitator to help the clients discover their "chemistry" with the art. The art consultant gives the painting its voice and allows it to speak to the admirer in ways that are meaningful.

Moreover, no one buys a piece of art... or a car... or a refrigerator. What people buy is what they perceive the acquisition will do uniquely for them. So the knowledgeable art consultant weaves a compelling sales presentation that takes into account the big MAC, archetypes, specific "sizzle", and factual information. The following sections will help you to devise sales presentations for your artists and your clients.

Components Of The Sales Presentation

The sales presentation has some important components. For example, the "sizzle". Director types long for include prestige, luxury, convenience and freedom from details — because they are busy people who are highly respected and therefore do not like to handle details. Filling emotional needs like these will cement a sale because what we've discovered is that ninety-five percent of our decision is based on emotion, and only five percent is based on logic. Experts tell us, in fact, that most of the time we make an emotional decision and then we apply logic to justify the decision. We seek out logical information to rationalize and justify our emotional decision. On the surface it might seem like, "Well, I should just talk entirely about how beautiful and exquisite the piece is, how popular the person is going to become, et cetera, et cetera, and not say much about logic." In actuality, of course, that doesn't work very well because it sounds pretty glib and superficial if all you do is stand there in the closing room and say, "Isn't that

beautiful? Isn't that captivating? You're going to become popular, and you're going to have fun and dah-dah-dah-dah." This isn't going to work. But, as long as you understand what's really happening psychologically, then you're OK. It is important to the sizzle. In fact, many of my art consultants forget to do that, believe it or not. They spend an inordinate amount of time on factual information. "Let me tell you where the artist was born. Let me tell you how old he is. Let me tell you where he went to school." Facts, facts, facts. "Let me tell you how many hours — ." They act like everyone's an Analyst. "Let me tell you how much time he spends on each original painting. Let me tell you where the graphics are printed. . ." So, the competent art consultant — the art consultant who makes a hundred-thousand dollars a year knows that s/he has to present a carefully woven sales presentation in order to make those sales. You have to appeal to the emotional self, with the logic as backup. This is a format that I encourage.

There are three components of each selling point you wish to make: (1) FACTS, (2) ADVANTAGES, and (3) BENEFITS.

A Fact is data, statistics and/or circumstantial opinion. Now, in our business I use the term "circumstantial opinion" for things like, "Hisashi Otsuka is world-renowned." Now, that's not something you could scientifically prove, if you will; but it's safe to say that because he has collectors in the Orient and in Europe, as well as in the continental U.S. and Canada, "Hisashi Otsuka is world-renowned." Circumstantial opinion should be put into the Fact category.

The Advantage is the reason you mentioned the Fact; it provides rationale.

CONSULTANT: "The reason I mention that to you, Mr. Collector, is that you indicated that the only kind of artists you collect are of world-renown stature. I know that's really important to you, isn't it?"

A Benefit is the emotional sizzle that pinpoints for the client that a piece of fine art or sculpture will be uniquely for him or her.

CONSULTANT: "And, as a matter of fact, Mr. Collector, I am absolutely certain that after owning an original Hisashi Otsuka, the prestige of that ownership is going to be practically unsurpassed."

You might decide, at one point, to just hit a whole bunch of sizzle, and then, hopefully, it's effective enough, and you'll say to yourself, "Gee, I'm not really getting through. I'm forgetting that I'd better say something here about who collects Hisashi

Otsuka." The important thing is to say whatever you choose to share with a client purposefully.

By the way, what's the easiest way to get a recognizable name as a collector? Give it away. Now, some people don't like that. It's a personal decision. I think it's an excellent way to get started toward world-wide recognition. I mean, what the heck — you've got to get started — and then the recognition desired will come to fruition — assuming the artist is, in fact, very marketable and talented. What's a good way to give it away - to get the most out of it?

I'm going to go all the way to the extreme. You're just a tiny gallery, and all your collectors right now live in the neighborhood. One way to go about doing this is to focus on a big event that's in your town that gets press coverage. It might be on the life-style page, but it doesn't matter. A big name is involved. It might be a political figure. Maybe it's the Governor of the State, for example. You make arrangements to give a piece of art to your Governor at the event when he makes his opening comments. At the function there is an unveiling of the gift. The painting relates to the theme of the event. That particular painting, you simply donate. A charitable organization is sponsoring the whole thing. They have the opportunity to turn around and auction the piece if they want and get cash. Or they can keep it. Whatever they want to do, it's theirs. That's just one example, and there are variations on that theme.

The Sales Presentation Builds Passion

The sales presentation builds confidence within the client that his/her investment is a wise one. While the motivation to acquire a fine collectible is emotional, clients require a logical basis for their emotional decision.

I have devised a four-page Artist Information Tutorial Format that is the minimum information an art consultant must have available to build an effective sales presentation. Art gallery owners should provide such information to all art consultants, brand-new as well as senior-level.

The art gallery owners I work with who are particularly progressive provide the four-page tutorial on every major artist to the art consultants on their first day of work. Four weeks later, the art consultants are given a written, closed-book exam. Quite often, the newest art consultants (who will all have been tested), begin to dramatically outperform the senior art consultants (who were not tested)! The new art consultants most certainly sound more savvy and become confident sooner.

One way to practice developing effective sales presentations is to brainstorm the key words of each component (Fact, Advantage, Benefit) while reviewing an Artist Information Tutorial.

Review the Sample Sales Presentations and then brainstorm the following tutorials or your own artists' biographies. Make your notes on the work sheet below. Remember:

A FACT "is"; an ADVANTAGE "is better because"; and a BENEFIT "does."

Said another way:

1. A FACT is data, statistics, and/or "circumstantial opinion."

2. An ADVANTAGE is the reason you mentioned the fact. It often draws a comparison or provides a rationale.

3. A BENEFIT is the emotional sizzle that pinpoints for the client what the fine art or sculpture will do uniquely for him or her.

FACT	ADVANTAGE	BENEFIT

SAMPLE SALES PRESENTATION — Key Words/Phrases Format

Frederick Hart

FACT	ADVANTAGE	BENEFIT
World renowned	Has already "arrived"	Prestige, peace of mind
Realistic sculptor	Classical Form	Timeless
Classical sculptor using contemporary materials	Progressive "ahead of his time"	Unique
Durable quality	Museum won't crack, bubble...As evident, number of museums	Family heirloom Affordable legacy
Smithsonian Magazine Church,	Benton	Homer Value
16 pages are in same issue	Critical acclaim	Greatness assured
45 years old	Creative peak	Acquiring the best
Opportunity to meet in person	Become part of history	Own a piece of history, status
9th grade test scores	Result: Child prodigy U.S.C.	God given talent
Won international competition-cathedral	The best of the best	Prestige
National War Memorial	Created a symbol of a generation	Michelangelo of 20th Century
Works in Lucite	Creates effects in light & dark	Unique to the medium

SAMPLE SALES PRESENTATION — Paragraph Format

Hisashi Otsuka

FACT-ADVANTAGE-BENEFIT SHEET

FACT: Otsuka is unique. ADVANTAGE: He is a "one of a kind" artist. BENEFIT: You have the opportunity to possess a work of art that is very special.

FACT: Otsuka has had arduous training. ADVANTAGE: He has, thus, risen above his contemporaries. BENEFIT: He paints with painstaking precision to provide truly unique works of art.

FACT: You will never see anything like his work. ADVANTAGE: People coming into your home will be amazed. BENEFIT: You can be assured that your vision of fine art reflects good taste and will be "your personal discovery to share with your world."

FACT: Otsuka's training has been extremely difficult; his level of expertise assures us that there can be no imitators. It took seventeen years of dedication for him to rise to his current level. ADVANTAGE: His creative talent combined with his immense skill creates pieces never before seen by the world. BENEFIT: His works of art are unique.

FACT: Color combinations are original to Otsuka's world. His incredible color sense was developed by spending two years with his master doing nothing but mixing colors. ADVANTAGE: His colors are always pleasing to the eye and are not found in the works of other artists. BENEFIT: His paintings are always decorative and provide unsurpassed beauty in the owner's home.

FACT: Otsuka's paintings are as intricate as the finest miniatures but are on a grand scale. ADVANTAGE: He creates the finest detail work human capability allows. BENEFIT: He brings the paintings to new levels of accomplishment never before attained.

FACT: Otsuka's training was that of the ancient kimono painters who worked on fabric. ADVANTAGE: Such painting on fabric is the most difficult type of painting. BENEFIT:

You have the opportunity to own a work of art that very few artists could even attempt to create due to the exclusive training required to achieve this expertise.

SAMPLE ARTIST TUTORIAL

ARTIST: Hisashi Otsuka

PHILOSOPHY: Perfection - In Japan, it is a tradition for contemporary artists to retrace the inspiration of the old masters and to make that inspiration come alive again. This rediscovery is a noble yet futile attempt at achieving perfection; to refine what has already been refined over the centuries is to come closer and closer to the "perfect work of art."

"This ideal motivates my every painting. I build upon traditional themes while creating art the likes of which the world has never seen." East meets West in a triumph of style, color, and detail.

STYLE: Contemporary Japanese and Neo-Deco

TECHNIQUE: Works primarily in kimono inks (mineral and oil based) on fabric (Kipula). Published works are mixed-media graphics: lithography, serigraphy, sculptural embossing, mezzotinting, and metal foil stamping. A silk texture is applied to the image surface (double thickness, acid-free paper), and a mother-of-pearl coating in the fibers recreates the iridescent quality of the fabrics upon which he paints.

APPRECIATION
HISTORY: Originals have quintupled in value since 1980.

COLLECTORS: Sophia Loren

Donna Summer

Sergio Mendes

Dolly Parton

Mark Hamill

United Nations University

Hira Mikijiro

Sachiko Kobayashi

Merle Lam

BACKGROUND/
CREDENTIALS: Otsuka was born in Tokyo, Japan, in 1950. He trained in the traditional, almost medieval, apprenticeship system. Otsuka has emerged in the West as the acknowledged master of contemporary interpretation of Japan's past.

At age fifteen he became the apprentice of Tateo Jo, one of Japan's eleven exalted masters in kimono design. After undergoing ten years of rigorous Samurai-like training, Otsuka was instilled with the warrior code of duty, dedication, and discipline. For example, for the first three years, Otsuka was allowed to do nothing but menial tasks: clean brushes and mix colors — to learn discipline. Finally, he was allowed to paint, and even then the master would have Otsuka practice specific strokes for days on end.

Otsuka was acknowledged by his teacher as the finest student who had passed through his school. He was told by his master that he had surpassed his own teachings. This is the ultimate compliment that can be paid to a student in an apprentice relationship with a master.

Otsuka then went on to work in a kimono design factory where his designs became so popular that Westerners started buying the

kimonos and framing them to hang in their homes. This is what gave Otsuka the idea of mounting and framing his silk creations.

Through the consummate drama of Kabuki and Noh theatre, the elegance of Heian Dynasty calligraphy, the grace of eleventh-century lords and ladies, the timeless beauty of Ukiyo-e women, the serenity of sumi-e, and the heroic power of the Samurai, Otsuka gives us an insightful link to an ancient culture.

Today, living and working in Hawaii, where he has resided permanently since 1981, Otsuka pursues his self-appointed mission in life to share with the world the vivid past that forms the traditions and history of one of the world's greatest cultures.

SIZZLE: Precision — Otsuka paints with uncompromising detail and precision. His pieces are as intricate as the finest miniatures but on a grand scale. He creates the finest detail work human capability allows. His kimono inks are indelible, and once filling the pore of the fabric, they cannot be removed or altered in any way. Each finished piece is a triumph of dedication, patience, and precision.

Color — Otsuka's color combinations are unique to his world. His incredible color sense was developed by spending two years with his master doing nothing but mixing colors. Most people are drawn to his work because the colors are pleasing to the eye and enhance the decor.

Arduous Training — Otsuka's training has been so difficult and his level of expertise so high that we are assured that there will be no imitators. Painting on fabric with the detail and precision exhibited by Otsuka is a "young man's game." Age eventually will force him to adopt a looser and more stylized painting method. He is at the

height of his creative power, and work acquired now will no doubt be considered the most significant of his career.

History, Japanese Culture, Legends — Otsuka's works are inspired by Japanese history and culture. This allows our clients to learn and experience another culture.

The legends/history provide a source of interest and conversation that clients enjoy sharing with friends. They also give substance and long-lasting intrigue to each piece.

His work is a unique fusion of old and new, East and West. This offers us new styles and outlooks through artistic expression that assure the clients that they own something new and fresh.

Prestige — Otsuka is collected by the "rich and famous" around the world. This puts the client in "excellent company."

Otsuka has received critical acclaim. In 1982, he was selected as the New York Art Expo's featured artist. The New York Art Expo is the largest art exposition in the world, and 1982 was the first time in history that an Eastern artist had ever been honored as featured artist of the Expo (which is predominantly a European and Western Art Expo).

HANDLING COMMON OBJECTIONS

Remember, whenever you address any objection, always empathize with the client before "overturning" it. Also, objections are simply concerns that express a strong desire and the need for more information to justify the acquisition.

1. "IT'S TOO BOLD/STRONG/DRAMATIC AND OVERPOWERING."

 Fine art "lives" and takes on its own unique character in its new "home." Viewed in isolation, this piece might seem overpowering, but in your home, it will complement your environment rather than monopolize it. It will create a focal point of drama with the piece as center-stage. Isn't that why we acquire fine art in the first place?

2. "WON'T FIT; TOO ORIENTAL."

 His Japanese cultural themes provide substance and richness that will keep the piece "alive" for generations. The symbolism, while "Japanese," represents universal concepts that everyone can appreciate.

 Framed properly, his work can complement most any decor. I have clients with _____ (traditional, country, eclectic, etc.) decor similar to yours, and they framed it in _____ (describe framing). This made the piece "work beautifully."

3. "HIS ORIGINALS ARE TOO EXPENSIVE, AND BUYING A REPRODUCTION IS LIKE FALLING IN LOVE WITH ANOTHER MAN'S WIFE."

 If you love Otsuka and prefer originals, you should have one. His originals are contemporary masterpieces that are becoming less available as time goes on. Extraordinary worldwide demand dictates that he publish to make his work more available.

To acquire an Otsuka original for $ ____ today would be like acquiring a Rockwell ten years ago. If we wait much longer on either account, the works will no doubt become "priceless."

While it would have been nice to have invested years ago, Otsuka is still a young man. His work should continue to appreciate, which makes today just as much of an opportunity.

If you love Otsuka's originals but can only acquire a fine graphic at this time, you are in great company. People with unlimited resources such as ____ (name collectors) have Otsuka's graphics in their collections because they love them. His graphics are the finest man and science can achieve.

SAMPLE ARTIST TUTORIAL

ARTIST: Andrea Smith

PHILOSOPHY: Balance — We are all sparks of the same flame. This, in turn, creates the natural balance in life, our lives, and my paintings.

Many of my paintings show the symbol of male and female together. My message is twofold:

A marriage between two people requires balance in the relationship in order for it to prosper, and...

Each of us has maleness and femaleness within, which thereby necessitates a delicate balance for every person. This is often described as the left and right functions of the brain. The left dictates logic and order while the right determines our nurturing and creative abilities.

Thus, each human being seeks balance within, as does each relationship, community, nation, and finally, our world. I celebrate through my painting to create in the world a harmony of understanding without the impulse to control. World peace begins with each of us as individuals.

STYLE: Surrealist and Abstract Expressionist

TECHNIQUE: Works exclusively in watercolors on acid-free paper (Arches and Fabriano Paper), which ensures the colors will never fade.

APPRECIATION
HISTORY: Originals have appreciated on average fifteen times in the last decade (1976-1986).

COLLECTORS: Merrill Lynch Corporate Headquarters, New York, New York

University For Peace, Costa Rica

Eric Von Lusbader, New York, New York

Hadassah Hospital, Jerusalem, Israel

Center for Attitudinal Healing, San Francisco, California

Barry Rand, Vice President of Xerox

John Taylor, President of Banker's Life

Sandra Myer, Vice President of CitiCorp

BACKGROUND/
CREDENTIALS: Andrea Smith was born in Detroit, Michigan, in 1946. She pursued a teaching career and received a B.A. in Education from Wayne State University. Throughout her ten year teaching career, Smith pursued her true love: painting. Originally she studied and perfected techniques of realism; she slowly began to reject that type of representational art form. After many years of inner struggle, Smith began to listen to her intuitive self and allowed "some unconscious or subconscious perception" to flow through her onto the paper.

In January, 1981, she moved to Maui with her husband and their two children. Now a confirmed resident of the Hawaiian Islands, Smith continues to emphasize the universal qualities of life through her work.

Smith has received critical acclaim throughout the world. Now, she is considered by many to be as unique as the genius of Picasso, Chagall and Miro.

SIZZLE: World Peace — Everyone can relate to the concept of world peace. She projects positive energy through balance, symmetry, symbolism, and color to celebrate her message to the world.

The Hopi and Navaho legal defense fund requested Smith's imagery for their national campaign due to its "peaceful flow."

University For Peace supports Smith's work; she was selected to do their 1986 Calendar.

Color and Balance — Many people respond well to her color schemes and symmetry.

She creates her work outside to capture the brightness and lifelike qualities of the art.

She works with the finest pigments and papers to ensure the integrity of the colors.

Her work is balanced; you can rotate it 180 degrees and still feel a strong sense of cohesiveness.

Complements any decor Properly framed, her work will fit well with contemporary, traditional, Oriental, or eclectic furnishings.

For an investor, acquiring a Smith is like obtaining a Miro in 1925. The investment potential is substantial.

Spiritual Many people who are students of "higher consciousness" (which includes many white-collar professionals, physicians, educators, "yuppies," etc.) relate to the symbolism in her work.

It has its own interpretation.

It is thought-provoking, a conversation piece. You always see something different.

If you look hard enough, you will find yourself.

Her works are "mind scapes" of the imagination that live and breathe with every glance you take.

HANDLING COMMON OBJECTIONS

Remember, whenever you address any objection, always empathize with the client before "overturning" it. Also, objections are simply concerns that express a strong desire and the need for more information to justify the acquisition.

1. "I USUALLY COLLECT CANVAS WORK; I'M CONCERNED ABOUT WORK ON PAPER."

 Framed properly, it will last many lifetimes/centuries. The ancient Egyptians printed on paper; pieces are still intact today.

 Smith uses only the finest archival (acid-free) paper; this guarantees the colors will never fade.

2. "I HAVE NEVER HEARD OF HER."

 That is why you want to acquire it now because you will be hearing about her. She is considered an emerging artist.

 Acquiring a Smith today is like obtaining an original Miro in 1925. What an exciting opportunity (prior to being published); as an emerging artist she is still affordable.

3. "I HAVE ONLY ACQUIRED TRADITIONAL ART WORK IN THE PAST," or "MY TEN-YEAR-OLD COULD DO THIS."

 And aren't young people intuitive? I think one of the things many adults admire about young people is their ability to see the world in a "naive and fluid yet inner-connected way." Smith surrenders to the naive child within us all that says, "World peace is possible."

 Fine art is a "window" to your inner thoughts. We all have a wonderful range of emotions within. This piece will be the "blue" in your rainbow of emotions.

Smith's art "lives." Unlike traditional art that is photographically accurate, her work takes on new meaning each and every time you gaze at it. Think of it, a lifetime of new discovery awaits you with this piece.

4. "I LOVE IT, BUT MY HUSBAND (WIFE, PARTNER, ETC.) DISLIKES IT."

I encourage you two to take turns selecting your prized collectibles. It is almost impossible to find something that you both love equally, and to always compromise on pieces can render them all "lukewarm." Acquire this for yourself, and next time help him/her choose his/her special piece.

This is the type of art that endears itself more and more over time.

SAMPLE ARTIST TUTORIAL

Artist: The Makk Family (Eva, Americo and A.B.)

Philosophy: VISION: We strive to gain insight into our subjects and capture their innermost realities. We wish to pierce through all barriers and go beyond to those areas of self that even our subjects may not be aware of. Thus, we strive to create not just a mere image or "picture", but also to reflect the subject's aura, spirituality, inner self, and to create a feeling in the viewer that allows one to momentarily "connect" with the subject. Our goal is not to illustrate but rather to illuminate.

Style: Americo — Impressionism combined with realism

 Eva and A.B. — Impressionism

Technique: Works are primarily in oils on canvas, with original watercolors and limited edition serigraphs on acid-free paper.

Appreciation
History: Original oils have appreciated on average 10 times in last decade.
Awards And
Major Works: Portrait of Cardinal Mindszenty, Vatican, Rome

 Portrait of the Governor of Manaus, Brazil

 Historical mural, Metropolitan Cathedral of Manaus, Brazil

 Portrait of President Reagan, Washington, D.C.

 Portrait of President Carter, Washington, D.C.

 70 International Awards and Gold Medals including Italy's Academy of Fine Arts and U.S.A.'s Arpad International Academy Award.

The Makk's have exhibited at embassies, galleries, and museums throughout the world over the last 30 years including: Budapest, Paris, Rome, Venice, Florence, Verona, Madrid, Nice, Munich, Vienna, Caracas, New York, Washington, D.C., Miami, New Orleans, Dallas, Chicago, Las Vegas, Los Angeles, and innumerable other cities on four continents.

They were honored by the Academia Italia with the 1985 Oscar D'Halia Award for most significant contemporary artists in the world today.

Background/
Credentials: Americo was born in Hungary in 1927, and studied at the Hungarian National Academy of Fine Arts in Budapest. Upon completing his studies, he received a scholarship from the Italian government which enabled him to study further in Florence, Venice, and primarily at the Academy of Fine Arts in Rome. Americo was inspired by the Renaissance Masters: Da Vinci and Michelangelo.

Eva was born in Ethiopia, Africa. Her mother was a Hungarian baronness and her father was an economic and agricultural advisor to Ethiopia's Haile Selassie. Eva studied at the Academy of Fine Arts in Paris and completed special studies at the Academy of Fine Arts in Rome. Eva was inspired by Renoir, Cezanne, and Monet.

Americo and Eva met while each studied at the Academy of Fine Arts in Rome. Americo says of his first glimpse of Eva, "I saw her from a window; she was the most beautiful woman I had ever seen. I knew I had to meet her."

Their marriage in 1950 also proved the catalyst for a merger of painting styles. This allowed them to create historical murals and

ceiling works in fourteen churches, government buildings, and cathedrals that surpassed anything ever painted.

Together in the Metropolitan Cathedral of Manuas, Brazil, they created the largest single theme painting in the world (surpassing Michelangelo's ceiling mural in the Sistine Chapel).

They went on to become the most significant contemporary painters in the world today. They have received 70 international awards and gold medals, done three presidential portraits, have been featured in dozens of national magazines, and have received gold medal first prizes from European and American Academies.

Their son, A.B. (short for Americo Bartholomew) was destined to become as great an artist as his parents. When he was four, the Brazilian press called him the "Little Picasso". Since 1976, A.B. has exhibited regularly with his parents, and today he is in the same illustrious class with Americo and Eva.

In 1967, the Makk family moved from New York to Hawaii. Their home and studios are located atop the beautiful Waialae Iki Ridge, overlooking the Pacific Ocean. Their surroundings provide them with the inspiration to create the wealth of fine art by the world's First Family of Artists.

Sizzle: Prestige — Many people appreciate the "first class" credentials and worldwide recognition the Makks have achieved. They project an aura of prominence both in their hard earned accolades and in the selected subjects they portray.

They have received over 70 international awards and gold medals, and they have painted several portraits of presidents, governors, Bishops and even one of a Pope.

Classic — Those who are attracted to the Makks' work love its classical imagery reminiscent of the old world masters. Indeed, the Makks have studied such masters as Da Vinci, Michelangelo, Renoir, Monet, Cezanne, and Rembrandt in the finest art academies in the world.

Complex — The Makks tackle a variety of themes, but each piece is characteristically complex and of obvious difficulty. Their skills garner appreciation of their collegiate and life-long study of composition, color, perspective, and light.

Complements any decor — Their work will fit best in traditional decor and in homes with antiques (such as from the Chippendale, Queen Anne, Emporium and Adams periods). Framed properly, their work will also complement contemporary, oriental, and eclectic decor.

Emotion/Vision — When viewing the Makks' artwork, many people are moved by the revelation of the subject's mood, personality, and feelings. The attitude of the face, the subject's posture, partially dropped eyelids, the tilt of the chin as well as subtle interplays of shadow and light, are suggestive of inner feelings.

People comment on how they connect with a piece via "alter-egos", true selves, past lives, attachment to bygone eras, and/or the aura of sadness/quietude/joy, etc. that is projected.

Established Artists; The Makks have already arrived, and substantial appreciation should be achieved, as it has been historically with other outstanding artists.

HANDLING COMMON OBJECTIONS

Remember, whenever you address any objection, always empathize with the client before "overturning" it. Also, objections are simply concerns that express a strong desire and the need for more information along with reassurance.

1. "Too expensive; how can they command such high prices?"

 While it would have been nice to have acquired a Makk years ago, and thus made a huge profit already, they are still experiencing significant appreciation. Their work should continue to appreciate in value, which makes today just as much of an opportunity.

 Their fine quality serigraphs from their very own serigraph studio are very affordable. The editions are small (less than 300) and have won international acclaim as the best serigraphs printed in the world today. These serigraphs provide an excellent way for any collector to get started.

 The Makk family is considered "The First Family of Fine Art" and are the finest contemporary artists in the world today. I suspect that future generations will make their works essentially priceless; only museums and people of extraordinary means will find a Makk original in their collection. We are fortunate today that they are even available.

2. "Won't fit; my home's decor is contemporary; definitely not traditional."

 Framed properly, I think you will find this piece will complement your contemporary home. Many of our Makk collectors have such homes and have opted for framing like the one you see over here. Doesn't that seem like it would make the transition beautifully?

 Fine art "lives" and takes on its own unique character in its new home. Viewed in isolation, this piece might seem too traditional, but once in your home, it will compliment your environment.

This Makk piece you're admiring is something that touches the inner you, and in that sense will be an asset for your soul. A mere gaze will take you back to Paris and your lovely time there...

3. "The proportions seem off/it looks unfinished?"

This is the beauty of impressionistic artwork. The image isn't a photograph, but rather a soft expression of the subject conveying mood, balance and motion. The subtle interplay of dark and light create mood even in the shadows.

The soft fuzzy edges provide an easy entrance into our imagination; after all, impressionism allows us to place ourselves in the painting,... the old woman in the distance is our own grandmother; the garden party is our own; the Parisian scene is filled with our friends, the nude's face becomes the vision of our own lover.

Four Key Categories

I'm going to give you the four key categories for which your art consultants have to have the information at their fingertips in the dimmer room. Remember, the more time you spend, the more results you achieve — but you have to have something to say, and it's got to be meaningful.

Number One — You've got to have something to say about style and technique.

Number Two — You must know about background and credentials. If the person doesn't have a background, you create one. I don't mean you lie. I'll give you an example. I worked with Michael J. Robinson, who had not achieved national recognition at this point. He is an absolutely great artist. I loved his work. I remember the first time I met him. He was a very self-effacing guy, very attractive. And I said, "Gee, Michael, tell me something exciting about yourself."

ROBINSON: "There's nothing to tell. I just paint."

ZELLA: "C'mon, Michael, there's got to be! (I was filling in for Andrew Fisher at the time, who was on a lengthy vacation in Europe and had me fill in as the Director of Sales while he was gone. I wanted the sales team to sell a lot of Michael's work.)

ZELLA: "Why don't you come down and share some of your background with the sales team?. But give me some information now because I'm going to have it typed up and make it available to them."

ROBINSON: "Well I really like Hisashi Otsuka."

ZELLA: "Michael, c'mon. Tell me about yourself."

ROBINSON: "Well, I spent some time in Europe, and I was a graphic artist first (he named some big-name companies), did some big spreads for some magazines, etc. But that's not really art, not fine art. And I've never been to school. I've never trained formally."

ZELLA: "That means you have natural talent!"

The conversation went on and on and on and when all was said and done, I ended up with about a two-page handout for the art consultants. The other thing I asked him about was his inspiration.

ZELLA: "Tell me, what compelled you to paint that image?"

ROBINSON: "Oh, my gosh, I saw this woman on the bus in Honolulu, and she just looked like the Hawaiian women of long ago, and I wanted to paint her. So I had her put on a Hawaiian style, you know, the old-style dress and a lei, and I had her dance out on the beach at sunset doing a hula. And I just was inspired."

She was just a young girl, and it was simply a fascinating story. Anyway, we sold out that series of paintings in the next few months. When the salespeople heard that, suddenly his work came alive. Instead of saying, "Oh, Michael J. doesn't have any formal training," say, "Michael J. Robinson has natural-born talent. Imagine, never having instruction and creating that. Can you imagine that? What can you draw? Try to draw something here." That's just one example of how you can change someone who in his own mind and heart thinks that he doesn't have anything to offer in the way of credibility into someone special.

Number Three — Appreciation History is something that we want to highlight. "This particular artist's work has appreciated five times over the last

decade." "This particular artist's work has appreciated dramatically, and I have no doubt it will continue to do so in the future."

Number Four — Major Collectors and Awards we've already talked a bit about and should be stressed. By spending time with the prospect in a give-and-take dialogue about these four key categories, you will successfully build value.

SAMPLE SALES PRESENTATIONS FEATURING FOUR KEY CATEGORIES

Review the following sample sales presentations. I have pulled each together from their respective artist tutorials or biographies. Please do not take the similarities to be an indication of lack of imagination on my part. Rather, I have specifically chosen to use the same line of thought for three very different artists. I just replaced specific details as needed so you could get a feel for my systematic approach to this otherwise nebulous mass of information.

A SALES PRESENTATION FEATURING FOUR KEY CATEGORIES

LOGIC *EMOTION*

Style & Technique

Fact: Neiman uses long- Benefit: His paintings are destined
 lasting materials; e.g. to become family
 acrylic on canvas and heirlooms.
 bronze.

Advantage: His works will last
 "forever" or at least
 longer than several
 generations.

Background & Credentials

Fact: Neiman is arguably one Benefit: You can rest assured that
 of the most famous and you are acquiring the best
 popular visual artists in according to *Art in*
 the world. *America.*

Advantage: His biography appears in every major volume of "Who's Who". This demonstrates that he is firmly established, critically acclaimed and recognized throughout the world.

Appreciation History

Fact: He has a successful track record.

Advantage: You can acquire a Neiman piece while his work is still appreciating.

Benefit: You rest assured that what you acquire today will be worth more tomorrow.

Major Works & Collectors

Fact: Neiman's collectors include Bob Hope, Hugh Hefner, etc.

Advantage: His work is appreciated by those with unlimited resources. They can acquire whatever suits their tastes.

Benefit: The prestige associated with owning a Neiman is practically unsurpassed; you are in good company.

A SECOND SALES PRESENTATION FEATURING FOUR KEY CATEGORIES

LOGIC *EMOTION*

Style & Technique

Fact: Americo Makk uses Benefit: His paintings are destined
 long-lasting materials; to become family
 e.g. oil on canvas. heirlooms that span
 generations.
Advantage: His paintings will last
 "forever" or at least
 longer than we or our
 children's children.

Background & Credentials

Fact: Americo Makk is Benefit: You can rest assured that
 arguably one of the you are acquiring the
 most famous and best.
 popular visual artists in
 the world.

Advantage: His biography appears
 in every major volume
 of "Who's Who" in
 Rome, London and
 America. This
 demonstrates that he is
 firmly established,
 critically acclaimed and
 recognized throughout
 the world.

Appreciation History

Fact:	He has a successful track record.	Benefit:	You can be assured that what in terms of appreciation, and yet... you acquire today will be worth more tomorrow.
Advantage:	You can acquire a Makk piece while he is still on his way up.		

Major Works & Collectors

Fact:	Some of Americo's major works include portraits of former Presidents Ronald Reagan and Jimmy Carter.	Benefit:	The prestige associated with owning a Makk is practically unsurpassed.
Advantage:	His work is appreciated by those with unlimited resources. They can acquire whatever suits their tastes.		

Summary

To pull together relevant facts for sales presentations for yourself and your team, follow these guidelines:

1. Call the artist, his/her publicist, or publisher to get every piece of information available about him/her. Do this for all of your important artists. I know that for some, this project will seem daunting due to the large number of artists you feature. If you have more than a dozen artists in your gallery, then start with the most "important" dozen first.

2. Construct an artist tutorial for each one. Don't overlook the option of using a freelance writer to do this for you. Enlist the aid of your team to develop these. While the background, credentials, list of collectors, style, and technique can be distilled from step 1, the "Handling Common Objections" and the "Sizzle" sections can best be derived through brainstorming sessions. Just make certain that someone takes copious notes and that these notes are refined into some final copy.

3. With the tutorials in hand, brainstorm as part of your sales meetings prior to shows, direct-mail, and phone follow-up programs. Embellish Fact, Advantage, Benefit statements in each of the four key categories discussed earlier.

4. Go through these exercises periodically as part and parcel of your complete marketing plan. Remember, this empowers you and your staff with the romance to build value, excitement, and passion!

I really hope you took the time to review the previous examples so that you will be equipped to design your own provocative sales presentations. If you noticed the strong similarities for each of the very different artists presented, then

you know how straightforward it is to create your own framework. Don't worry about sounding repetitious with your line of thought; the specific details of each artist's biography, along with the ever fresh words you choose to express the information, will make your presentations successful.

SECTION FOUR — PROFESSIONALISM

Introduction

If you want to appeal to the widest spectrum of people, there are some key things you have to keep in mind. Remember I said that you get an impression in the first seven seconds? Where does the bulk of that come from? Sometimes even the consultants who dress beautifully and are sophisticated with nice jewelry are seen chowing down a sandwich at the desk. The person the client sees has a piece of turkey in his/her teeth. "Oh, excuse me, let me go the men's room." The other thing that we tend to do, particularly in resort towns, is become too casual. They say they don't want to intimidate. Let me just share with you that I don't care what the clients have on; they could have on cut-off T-shirts! But what do you think is going on in their heads? If they see you looking a little bit too casual, one of the first questions they ask is whether you're a serious art consultant. Then, when they see something they like, they ask, "Can I speak to the owner or the manager, please?"

I also want to elaborate on the fact that in the first seven seconds the clients will determine for themselves your educational level, what your position is with the firm that you're associated with, what your potential is, whether or not you are meticulous, how many kids you have, what kind of car you drive, and what your house looks like. It is absolutely astounding. Remember: You never have a second chance to make a first impression.
 Men should wear belted pressed slacks, socks, covered shoes, and have trimmed hair. For the ladies, always, always wear a skirt. I have included in this section a reprint of an article by John T. Malloy who did an exhaustive study over a period of years. What he discovered was that the woman in a skirt always was perceived to have greater authority and a higher intelligence level, and she received more respect. To me there's no question... wear the skirt, not slacks.

There are many things to consider here. Women should also always, always wear hose. I can't tell you the number of times I've seen women without hose. If they think they can get away with slacks, then they put those little flats on, those little heels, and they paint their toes, so they think they're OK. Always, always wear hose and, except in the tropics, wear closed-end shoes. They have discovered that it is acceptable in the tropics to wear conservatively styled open-ended shoes with hose.

Hair & Style

Three safe ways to wear your hair are short, back, and up. Loose hair is very sexy and attractive, but it can be distracting. It sends out sexual cues which can undermine your sales presentations. If you wear your hair long, it should be styled or coiffed for a finished look, otherwise you run the risk of looking sexy or simply unprofessional. You should dress conservatively. I do. As a matter of fact, I dressed dowdy in my early business career. Even so, I would get innumerable improper advances at shows, etc. So I learned to play down my sexuality. The younger and less experienced you are in your career, the more important conservative dress is.

Now that I am firmly established in business (and the rest of the world has loosened up a bit in regard to women's business attire) I am having fun with my own sense of style. I can get away with this because typically "my reputation precedes me". Thus, when I show up with a stylishly sophisticated knit dress that has a dashing "V" of dazzling sequins, full coiffed shoulder length hair-do, and large glistening earbobs — heads turn. Most people in these settings already know who I am and are mildly "entertained" by my strong style statement, and those who don't know me will assume I am either eccentric or someone they should know! Strong style statements can be great for prospecting. I love it when someone comes up to me looking very expectant, and I thrust out my hand for a vigorous handshake. Since they have gone out of their way to come to me, I don't

have to work as hard to get important introductions. This concept can serve you well in a gallery setting, show, or reception should you be inclined to indulge in some fun with style.

A strong style statement when carried off well can reinforce important qualities you may wish to exude: boldness, assertiveness, self-assurance, and strong-mindedness. Exuding such qualities certainly comes in handy for me as an art dealer and as a business consultant.

Those of you who wish to make a strong style statement may want to track down an out of print book, entitled, *Metamorphosis* by David Kibbe. Some libraries and rare book stores may have it. The reason I recommend this book so highly is because it is, without a doubt, the finest piece ever written on how women can make the most of their individual physical attributes while exuding the physicality complementary to their own inner strengths. For the life of me, I can't imagine why it's no longer available. Everyone I have shown my copy to immediately asks to borrow it and then she never wants to give it back! By now, it is literally falling apart and nearly shredded from enthusiastic style seekers. The information is really useful due to his comprehensiveness, before and after photo's of real women, conversational tone, and emphasis of accepting one's own special qualities vs. "hiding" them For all of us non-fashion experts, this book is a "MUST".

Women and Power

We are more powerful than the guys. It's because we are so well-schooled, by virtue of experience, in not having an ego struggle with people and in being very complimentary to people. We are more intuitive than men tend to be because we have to be. We have a much greater tendency to have a knee-jerk reaction to Mr. Director of deferring and giving him his propers than have the men. And our likelihood, in the long run, of believing, "Wow, I'll immerse myself in this

business" is absolutely incredible because we are quiet fire — powerful. We're in control, and they don't even know it, and that's the flip side; so do the right thing: maximize your opportunities.

The Men

But men, you guys have an advantage, what can I tell you? All you have to do is try. I really envy you men. Just wear the same suit every day, change the shirt, and that's it, and you've got it. So, that's wonderful. The biggest mistake that men make is they don't shine their shoes. It isn't that popular anymore. I don't know why, but people don't shine their shoes anymore, and it looks tacky.

Appearances aside, another mistake I observe is the "holier-than-thou" attitude many men exude. It is, no doubt, some fallout from prehistoric man that was important for fighting bears to survive and protect one's family. But hey; wake up! It's the nineties, and unless you live in Yosemite, you won't be wrestling any bears any time soon. So, my advice to those of you with big egos is ... RELAX. You will do your wife and kids a favor by living longer. And as an added bonus, you will be more attentive to your clients and make more sales. Along these same lines, please be open to learning. Ask questions; gain a sense of humility. In addition to gaining the benefit of your selling more art, this world will become a better place.

Lastly, review the shopper's survey that follows. You'll want to make a photocopy of this, and from time to time you'll want to hand it out to your people or to yourself. Go out and do a shopper's survey of any competitor that you admire. Choose someone who you think is particularly hot. You should review the sheet ahead of time, and then go in. You will therefore have certain things on your mind that you will want to pick up on. Are they greeting properly? And immediately after you leave, fill out the survey, and don't forget the most important thing here. Do you see where it says "Comments" on the

lower left? What kind of image do the people convey? And why? And what can we do to create a better image and better service? The other thing you want to watch is their way of closing. Another thing I would encourage when you complete the shopper's survey is professional courtesy. You might want to go in when the traffic is slow, so that you don't distract them from a potentially tremendous opportunity.

Professionalism In Perspective

The whole purpose of defining one's outside is to have congruence with one's inside. This facilitates effective communication, and you and your clients must communicate effectively before a sale can be consummated.

If you are a neat, orderly, service-oriented person, then your dress, manner and speech should reflect this. If you think you are this way and choose to be a sloppy dresser, blow your nose on your sleeve, and use poor grammar, then few will ever come to know and trust the "real" you.

Finally, review the Dressing Inventory in this section. It is by John T. Molloy. One of the key observations you will glean is that no one in the business world will ever tell you if you are not up to par with your appearance — not your boss, not your co-worker, and least of all, a potential client. This is one area you must come to grips with on your own.

PROFESSIONAL DRESSING INVENTORY

Answer YES or NO to the following questions:

1. Does your company have a written dress code?

2. Does your company have an unwritten dress code?

3. Do you feel you would have a better chance of getting ahead if you knew how to dress well?

4. If there were a course on how to dress well, would you attend?

5. Do you think employee dress affects the general tone of the business?

6. Do you think employee dress affects efficiency?

7. Do you think that a person's promotion could be held up because of improper dress?

8. Would a supervisor tell you that you were improperly dressed and that it was holding you back?

9. Does your company, at present, turn down people who show up at job interviews improperly dressed, on that basis alone?

10. If you were a supervisor, would you hire a person who doesn't know how to dress for an assistant position?

DRESSING INVENTORY
HOW 100 TOP EXECUTIVES DESCRIBED SUCCESSFUL DRESS
JOHN T. MOLLOY

Several series of questions were asked of 100 top executives of either medium-sized or major American corporations. The first series was to determine the most up-to-date attitudes on corporate dress.

These executives were shown five pictures of men, each of them wearing expensive, well-tailored, but high-fashion clothing. They were asked if this was a proper look for the junior business executive.
8 – YES 92 – NO

Next they were shown five pictures of men neatly dressed in obviously lower-middle-class attire, and they were asked if this was a proper look for the junior business executive. 46 – YES 44 – NO

Then they were shown five pictures of men dressed in conservative upper-middle-class clothing and asked if they were dressed in proper attire for the young executive. All 100 said YES

They were asked whether they thought the men in the upper-middle-class dress would succeed better in corporate life than the men in the lower-middle-class uniform. 88 – YES 12 – NO

They were asked if they would choose one of the men in the lower-middle-class dress as their assistant.
8 – YES 92 – NO

To 100 other top executives of major corporations, the following questions were submitted:

1. Does your company have a written or an unwritten dress code? 97 – YES 3 – NO
 (Only 2 had a written dress code.)

2. Would a number of men at your firm have a much better chance of getting ahead if they knew how to dress? 96 – YES 4 – NO

3. If there were a course in how to dress for business, would you send your son? All 100 said YES

4. Do you think employee dress affects the general tone of the office? All 100 said YES

5. Do you think employee dress affects efficiency? 52 – YES 48 – NO

6. Would you hold up the promotion of a man who didn't dress properly? 72 – YES 28 – NO

7. Would you tell a young man if his dress was holding him back? 20 – YES 80 – NO

8. Would you take a young man who didn't know how to dress as your assistant?
 8 – YES 92 – NO

MAKING IT
By John T. Molloy

"CLOTHING MAKES THE WOMAN"

WOMEN: IF YOU want to wear the pants in your office – don't.

Research into the effect of clothing on a woman's career has singled out pants as one of those items that give off all the wrong signals. The research says the wearer does not expect to be taken seriously, unless (surprisingly) it is in a sexual manner.

And the truly professional woman doesn't want her clothes to send a sexual message.

My researchers and I put the question"Would a woman in a pantsuit fit into your executive office?" to 500 executives in a cross-section of American corporations. Of those 500, 402 said no.

Then we administered a "twin test," a technique developed to measure the reaction of large numbers of respondents to a specific item of clothing.

THE TEST included two pictures of the same women, wearing two versions of the same blazer suit. In one photo the suit had slacks and in the other it had a skirt.

We asked the people taking the test to guess which "twin" was smarter, earned more, had a better education and a better job.

From 80 to 94 per cent of the time, the positive attributes were assigned to the picture of the woman in the skirt.

Male executives assigned the positive attributes to the skirted woman 94 per cent of the time while female executives made the positive association with the skirted look 88 per cent of the time.

This was one of the rare occasions when the reaction of the general public mirrored that of the executives. The skirted woman got the nod from the general public 84 per cent of the time.

I considered the results sufficient to conclude that a woman wearing a skirt will command more respect than the same woman in pants.

TO FURTHER TEST that conclusion, we went to 50 women who agreed to wear identical outfits with the one variable (slacks or a skirt) about a week apart.

They further agreed that for two years they would rate their authority at the end of each test day on a scale of 1 to 10.

In every case, the women reported a higher score for the skirt than the pants.

© Summit Press Syndicate

Professional Goals

Well, we end where we started with PLANS and GOALS. While you may feel your personal goals needn't be shared, your professional goals must be. If each art consultant owns ten percent of the business (by virtue of his/her ten percent commission) then each individual sales plan must be added together to determine the company's sales plan!

Review the following forms: (1) Professional Goals Sheet, (2) Client Information Sheet (two-sided), (3) Annual Goals, (4) Monthly Goals and (5) Annual Show Schedule. Use these or develop your own forms.

Last, as you make a hundred phone calls, write a hundred letters, lick a hundred stamps — while there may be no glory in these necessary tasks, your rewards are reaped from realizing the vision. Perhaps the following parable says it all:

> Once there were three brick masons working on a building. When the first was asked what he was working on, he answered gruffly without even raising his head, "Can't you see? I'm laying bricks!" When the second was asked, he replied, "Well, obviously, I'm building a wall." But when the third mason was asked, he looked up from his work with a far vision in his eye and said, "I'm building a cathedral so that all the people in the town may come and worship together."

PROFESSIONAL GOALS
FOR
YOUR GALLERY

1. $ _____ Sales GOAL for the month of _____

 $ _____ Gallery + $ _____ Other = TOTAL SALES

2. Number of "Create Opportunity" calls this month = _____

 _____ "Package Deals" _____ "Prospects"

 _____ "Ask for Referrals" _____ "Other"

3. What is your current greatest challenge, and how do you plan to "work on it"?

4. Status of Previous Month's Goals:

 What Goals did you ACHIEVE or EXCEED? Not Achieve? Explain.

YOUR GALLERY
825 Main Street • Anytown, USA 96813 • (800) 538-3907

SALES PLAN FOR MONTH OF:

Gallery: *Monthly Sales Goal:*

Sun	Mon	Tues	Wed	Thurs	Fri	Sat

Appendix

Sample Direct Mailouts

Financing Forms

NOTE TO A PROSPECT

Date

Dear Valued Client:

Thank you for your recent interest in _____ (title of piece) created by _____ (artist). As we discussed, _____ is world-renowned and is collected by such notables as _____, _____, and _____ (list three collectors).

I would really like to see you have this piece. I will be calling you by the end of next week to discuss how we can make it yours!

Regards,

Your Name
Art Consultant

NOTE TO NEW FIRST-TIME BUYER

Date

Dear Valued Client:

I thoroughly appreciated the time we spent discovering _____ (title of piece) created by _____ (artist). Your insights into the symbolism behind the piece were inspiring. It certainly seems destined that _____ (title) should hang in your _____ (home, office, dining room . . .).

I will let you know as soon as the piece has been shipped and call you to make sure it arrives as planned.

Thank you, again, for your support of _____ (artist). I firmly believe his/her work will continue to make a strong impact on the world of fine art.

In the final analysis, it will be collectors like yourself who will determine his/her ultimate success by how much of his/her art finds its way into your lives.

Sincerely,

Your Name
Art Consultant

NOTE TO PAST BUYER

Date

Dear Fine Art Collector,

Greetings from the world of fine art! I trust you have been receiving our newsletter and have been kept informed of all the new and exciting art we have available.

Enclosed is your updated certificate of authenticity for _____ (title) by _____ (artist). I am happy to report an appreciation of _____ % in the past year.

Also, please review the enclosed brochure on _____ (title) by _____ (artist). I believe you will find it to be an excellent complement to your fine art collection.

. .

Short paragraph
of "Romance"
specific to the piece

. .

I feel certain this piece will find a place in your heart and home. I will call you by the end of next week to discuss this exciting opportunity.

Warm regards,

Your Name
Art Consultant

YOUR GALLERY
825 Main Street • Anytown, USA 96813 • (800) 538-3907

NOTE TO PAST MULTIPLE BUYER

Date

Dear _____ (Artist Collector),

 Thank you for your continued interest in _____ (artist). Collectors like yourself have rallied behind him in recent years to make _____ (artist) the premier _____ (style) artist in the world today.

 Take a look at his most recent creation. The enclosed brochure captures some of the brilliance, excitement, and freshness _____ (artist) conveys, but it can only suggest the depth, intensity, and movement in the actual piece.

 I urge you to acquire _____ (title of piece) today. Call me at (800) _____ at your earliest convenience so that I can set it aside for you. Or, send a check for $ _____ which will allow me to make shipping arrangements. I look forward to hearing from you by the end of next week.

Warmest regards,

Your Name
Art Consultant

Financing

In order to remain competitive, it is important to have financing programs. The gallery should offer one or more of the following:

1. HOLDS

2. LAYAWAYS

3. GALLERY CHARGE CARD

One and Two are "financed" by the gallery, while Three relies on a national financial institution (e.g., Beneficial) to carry the financing. The risks for holds and layaways are minor because the gallery keeps the art "in house" until full payment is received. Lost opportunities arise when clients inevitably cancel or "drag out" payments. On the other hand, the charge card eliminates this. Further, the client obtains the art immediately, as with any external financing program. The benefits to this are great: (1) The gallery's cash flow is better maintained because the financial institution pays the entire lump sum upon client's credit approval; (2) All accounts receivable activity is eliminated (no more calls on delinquent accounts, no more reminder notes, etc.).

What follows is a sample Layaway program, including statement, client form, policy (for distribution to art consultants). This is a simple "paper" system. Once accounts reach a certain level, you should seriously consider a computerized system.

YOUR GALLERY LAYAWAY POLICY

Thank you for your investment of $ _____ in fine art. Your piece will be set aside at your request for _____ months. A _____ % deposit of $ _____ has been provided to secure your piece. The remainder is due in _____ equal installments.

Of course, our Layaway plan does not charge interest or levy any service charges. In order to provide you with this important service, we do require all minimum installments to be paid at least monthly. Contact your art consultant if problems arise.

Should your circumstances change, we will accommodate you as best we can, but because valuable art is set aside to provide a comfortable payment program for our valued customers, cash payments can be credited toward other fine art.

You will receive monthly statements, and your art consultant will be in contact to keep you updated on the world of fine art. Thank you, again, for your investment.

. .

I hereby acknowledge the above conditions and agree to provide YOUR GALLERY a minimum monthly payment for the fine art that has been set aside.

NAME _____

ADDRESS _____

CITY _____ STATE _____ ZIP _____

BUS. PHONE (___) _____ HOME PHONE (___) _____

_____ SIGNATURE

YOUR GALLERY
825 Main Street • Anytown, USA 96813 • (800) 538-3907

YOUR GALLERY LAYAWAY STATEMENT

Thank you for your recent investment in fine art. Your valuable piece has been put aside. This payment guarantees that your investment continues to be reserved only for you.

A minimum payment of $ _____ is due by _____

Your Consultant is _____

Your Account Number is _____

PREVIOUS BALANCE	$ _____
PAYMENTS/CREDITS	$ _____
CURRENT BALANCE	$ _____

Send payments to our Main Street location:

YOUR GALLERY
825 Main Street
Anytown, USA 96813
Attn: Accounts Receivable

If you have any questions regarding your statement, please call our office at (800) 538-3907, or contact your art consultant.

INDEX